Mimmo Jodice *Inlands*

"Inlands: Photographs by Mimmo Jodice"
Massachusetts College of Art, Boston
20 November 2001 – 11 January 2002

Exhibition curated by
David D. Nolta and Ellen R. Shapiro

augustea

MN
METROPOLITANA DI NAPOLI SpA

RITZ CARLTON

CAFFE VITTORIA

JAMES G. FITTS

Mimmo Jodice

Inlands

Visions of Boston

Curated by
David D. Nolta and Ellen R. Shapiro

Scientific Editor
Luca Molinari

Design
Marcello Francone

Editing
Rosanna Schiavone

Translations
Language Consulting

First published in Italy in 2001 by
Skira Editore S.p.A.
Palazzo Casati Stampa
via Torino 61
20123 Milano
Italy

Printed and bound in Italy.
First edition
ISBN 88-8491-135-4

Distributed in North America and Latin
America by Rizzoli International Publications,
Inc. through St. Martin's Press,
175 Fifth Avenue, New York,
NY 10010.
Distributed elsewhere in the world
by Thames and Hudson Ltd.,
181a High Holborn, London WC1V 7QX,
United Kingdom.

Acknowledgements

Lisa Tung
Associate Director of Exhibitions
Massachusetts College of Art

On behalf of Massachusetts College of Art, I extend our deepest thanks and appreciation to Maestro Mimmo Jodice and his wife, Angela, for their endless generosity and dedication to this project. Without their help and quiet supervision, this bi-continental exhibition would not have been a success.

As curators, Professors David D. Nolta and Ellen R. Shapiro were a godsend, lending their impeccable taste, considerable expertise, boundless energy and good humor while tackling all aspects of the project, however big or small: translating Italian, hosting dinners, providing transportation and penning the insightful essay.

We are indebted to Barbara Quiroga, whose stewardship of the funding of this exhibition resulted in a beautiful catalogue. It is with great pleasure that we extend our thanks to our Italian sponsors: Paola and Lucio Zagari and Augustea Ship Management, Salvatore Colantuoni and Alitalia Airlines, and Gianniegidio Silva and Metropolitana di Napoli. We are also most grateful to our Boston sponsors for their ongoing commitment to the arts and our College: above all Fidelity Investments Charitable Gift Fund, as well as Ermenegildo Zegna, The Ritz Carlton/Boston Common and Anthony Pangaro of Millennium Partners, Caffe Vittoria, James G. Fitts, Ferrari of New England, Barbara H. Lloyd and Martignetti Companies.

The works created in Boston for this exhibition required the assistance of colleagues and peers within the College as well as the Greater Boston arts community. In particular we would like to acknowledge President Katherine Sloan and Vice Presidents Johanna Branson and Richard MacMillan for their support of our exhibitions programs; Joshua Basseches and the Natural History Museum/Harvard University, Pieranna Cavalchini and the Isabella Stewart Gardner Museum, Judith Fox and the Davis Museum and Cultural Center/Wellesley College, Deborah Leff and the John F. Kennedy Library and Museum, Thom Roach and Gore Place, and Samuel Tager, Rubie Watson and The Peabody Museum of Archaeology and Ethnology/Harvard University for generously opening their institutions to the Jodices; Ryck Lent for making possible visits to eclectic and esoteric sites; Roberto Pietroforte for his hospitality; and Steve Haley and Metalwoods Workshop for framing. Many individuals at the College assisted with myriad aspects of the exhibition – from installation to promotion, from commandeering boats to imparting valuable information and yet more hospitality. Michèle Furst, Darlene Gillan-Duggan, Katryna Hadley, Jean Inglis, Rick McDermott, Laura McPhee and the Photography faculty of the College, Mia Schultz, Peg Turner, Amy van der Hiel, Sandy Weisman and Chris Wiley deserve our thanks. Their involvement contributed significantly.

Lastly, *mille grazie* to Luca Molinari and Skira Editore, for their lovely design, printing and distribution of this catalogue.

I wish to thank, from the bottom of my heart, all those who have helped to make possible my exhibition and my book on the city of Boston. Thank you especially to:

Ellen Shapiro and David Nolta, not only curators of the exhibition and authors of a profound and illuminating text on my work, but also the dearest of friends, working tirelessly for the show and the catalogue, following me with infinite patience, taking care of me, guiding me to an understanding of their city with wisdom and love.

Jeffrey Keough, Director of Exhibitions, Massachusetts College of Art, for his immediate, fervent and sensitive embracing of the project and for his willingness to share an exciting experience on the streets of Boston.

Lisa Tung, for her thorough impeccable work in fulfilling our every need and request.

Roberto Pietroforte, for his fraternal hospitality.

Laura McPhee, through whose personal kindness we met and made so many worthy friends.

Pieranna Cavalchini and The Isabella Stewart Gardner Museum, Judith Fox and the Davis Museum and Cultural Center Wellesley College, Deborah Leff and the John F. Kennedy Library and Museum, Thom Roach and Gore Place and Samuel Tager, Rubie Watson and The Peabody Museum of Archaeology and Ethnology/Harvard University, and all the other institutions and museums that generously opened their doors to me.

Paola and Lucio Zagari and Augustea Ship Management, Gianniegidio Silva and the Metropolitana di Napoli, Salvatore Colantuoni and Alitalia, for their consistent appreciation of my work and their ongoing support.

Luca Molinari, who reassures me and moves me by his rare gifts, his integrity, and for his sincere respect for the work of artists.

Mimmo Jodice

Contents

Introduction

Jeffrey Keough
Director of Exhibitions
Massachusetts College of Art

Boston is going to be a great city… if they ever finish it.
Anonymous tourist, 1973

Boston is a city of dramatic transformation. Historic stories of Boston's once grand hills being dismantled for fill to redefine the riverbanks, harbor and Back Bay are legendary. The devastating fire of 1872, the Public Gardens, the Emerald Necklace park system, the airport with its tunnels, City Hall Plaza and the elevated expressways have all had an enormous impact on the city, whether planned or unplanned. Of course, Boston's renowned, constantly changing educational, medical and cultural institutions help define the very core of what makes the city thrive and grow. Boston sometimes feels like it is the result of a grand living experiment rather than any master plan. With all this in mind, the idea of this city as a photographic subject is a challenging one.

The original concept to showcase Maestro Mimmo Jodice's photographs came from Professor David D. Nolta and Professor Ellen R. Shapiro, both highly respected teachers in the Critical Studies Department at Massachusetts College of Art. Their scholarship in the history of Italian painting and modern Italian architecture, respectively, was instrumental to the way they approached the work and curated the exhibition. The Jodices first visited Boston and the MassArt galleries in the spring of 2000. It was at this time that the possibility of exhibiting not only Mimmo's masterful work from Europe but also new photographs of Boston was discussed. Mimmo stated that what little he had seen of Boston had interested him very much. For almost forty years, Mimmo has brought his unique vision to bear on both urban and rural landscapes throughout Europe, Russia, Africa and China. His passionate interest in art history, architecture and archaeology permeates his work. Mimmo's remarkable ability to expose beautifully haunting images of subjects both familiar and unexpected is unparalleled. It is not surprising he found continued inspiration here in Boston.

Working in collaboration with contemporary artists on new and untested projects can be a risky proposition. Often it is a gamble fraught with unforeseeable pitfalls and wrong turns demanding great leaps of faith. Inviting Mimmo Jodice to photograph Boston was a guaranteed success from the start. In May of 2001, Mimmo and Angela arrived. Day after day, by car, train, boat or on foot they explored the city and its outposts. Some of the sites they took in could be described as classic Boston, others certainly not. Indeed, Mimmo seemed fascinated by the city's waterfront. He stated that in Italy, the relationship between land-dwellers and the sea felt very different, functioning somewhere between the useful and the spiritual. But here in Boston, it felt more like ambivalence. I spent a number of days trying to chauffeur Mimmo and Angela to the water's edge. They were extremely interested in the physicality of the Big Dig and its promise to redefine people's relationship to the water. A lot of the time Mimmo, camera in hand, would stand in my passenger seat with the vast majority of his slender frame protruding out of my vehicle's sunroof. From this high perch he would survey vistas and would often exclaim: «Vai! Vai!» or «Piano! Piano!» Inside, Angela would translate: «He wants you to speed-up,» or «He wants you to slow down.»
It was during one of these slowdowns on a ramp in the middle of the Big Dig that the Jodices experienced another regional classic: the Boston Driver, complete with expressive gesticulations. I asked Mimmo what exactly he was looking for and he told me that he wasn't sure, but that he would know it when he saw it. He piloted us through places I had no idea existed, including both abandoned and working industrial sites. Some were clearly posted "NO TRESPASSING – POLICE TAKE NOTICE", and indeed they did. I found that in such a situation it helps if the driver keeps quiet and everybody else speaks only Italian.

Mimmo has achieved something remarkable with his Boston photographs. Through his work we see the city anew and fresh. Mimmo has an omnivorous eye that devours the world around him, finding beauty in contradictions. He can seemingly breathe life into an inert piece of stone or capture the feel and speed of our modern lives. In a single frame, epic dialogues with mortality unfold as order does battle with chaos, or creation and destruction cancel each other out. He miraculously captures the fragile and transitory nature of our lives. In the end, Mimmo Jodice's photographs are about transformation, the essence of Boston.

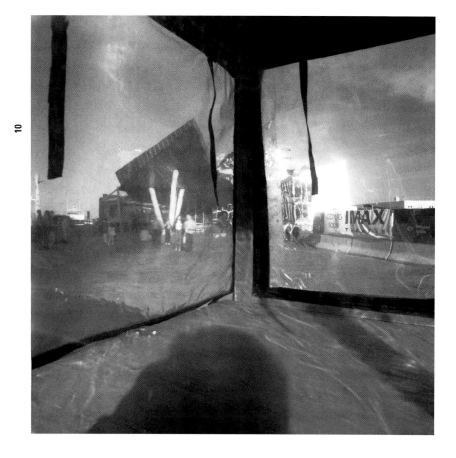

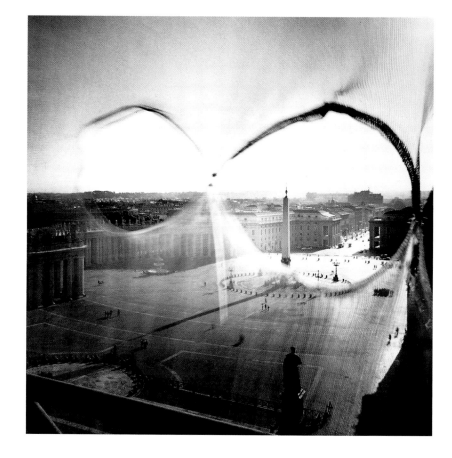

Inlands

David D. Nolta and Ellen R. Shapiro

A monumental city majestically presiding over the sea. An old city, steeped in history, a proud and self-conscious city secure in its heritage of military daring and political ingenuity. A city capable of being surprised by its own survival. A metropolis teeming with a distinctive living population, but also crowded with the ghosts of celebrated intellectual and pedagogical giants. An enlightened capital, and a locus of religious fervor and inquiry. A famous, and famously prosperous, port. A crucible of cosmopolitan cultures. A palimpsest of architectural evolutions. A city abounding in art, of which it is also the irresistible recurring subject.

These epithets describe at once Mimmo Jodice's native Naples as well as the town that is honored by his most recent photographic interpretation, Boston. In presenting the first photographs produced on American soil by this renowned European artist, we note certain convergences between the rich topographical and cultural histories of these two vital coastal centers. The outcome of Jodice's labors in New England, seen in the context of his Mediterranean vision, illustrates both the intriguing overlaps and the equally striking dichotomies between the two lands. In the finished work, we are confronted by original meditations on the real and imagined boundaries between the old and new worlds, the land and the sea, absence and presence, light and shade, form and void.

Elusive Shore

If the corpus of an artist's work often reveals one or more quests, then the overriding quest suggested by the works presented here is undoubtedly for the sea. Upon arriving in Boston, the photographer instantly embarked on a project to document the interaction between the city and its foundations in the water. In fact, the very first photograph Jodice took in Boston shows an elevated walkway in the airport, its decorated pavement swarming with aquatic creatures. In this image it is almost as though we are enveloped, Jonah-like, by the vertebrae of one of those creatures, which will recur, again in skeletal form, in later photographs taken at the Harvard University museums.

Water, then, was the goal of Jodice's initial investigations, and repeatedly throughout the Boston pictures we find evidence of the artist's attempts to

come into direct contact with the sea. But in Boston, unlike in the port cities of the Mediterranean, the shore, though visible, is elusive. A number of photographs poetically document the inaccessibility of the shore, obfuscated by rotting wood piles which recall the seamier aspects of the Venetian lagoon with no mitigating allusions to that city's Byzantine splendor. Other images, however, offer proof of a more serene and accepting *rapprochement* between artist and subject, between the city and the element out of which it arises. But it is when Jodice turns inland that he gains a new and unique intimacy with the water and all that it symbolizes.

The gesture of turning forcefully inland is superbly encapsulated in the photograph taken in front of the New England Aquarium. A close-up through two layers of the plastic shell of a sales booth transforms the steel and concrete masses of the Aquarium into an aqueous, ephemeral structure and imposes waves on the reflected image of the urban terrain. The view here eerily simulates the perspective of many of the marine animals housed within the building. In this multi-layered image, then, Jodice creates a synaesthetic equivalent of the water that has eluded him until now. Even more emphatic in its irony is the photograph of a diorama in the Museum of Science. Again, and as so often in the artist's work, Jodice views his subject through a barrier, in this case the perfectly transparent glass of the vitrine. His quest leads to an artificial lake complete with the requisite flora and fauna frozen forever in an eidetic likeness of a lost primal moment. Central to that moment, preserved as in a reliquary, water is revealed to be at once the source of life and artistic inspiration.

Observations of Architecture

It is hardly surprising that a primary theme in Mimmo Jodice's art is the relationship between water and architecture. Paradoxically, as we have seen, when the photographer does find himself in the proximity of the sea, he uses it as a foil for the metropolis and its ongoing metamorphoses. The steel skeleton of a bridge dramatically spans the water, tempting us away from it. The superstructures of the Financial District, edging out the crumbling wooden posts of deserted wharves whose shapes they airily imitate, nevertheless join them in beckoning to the viewer. In fact, the city

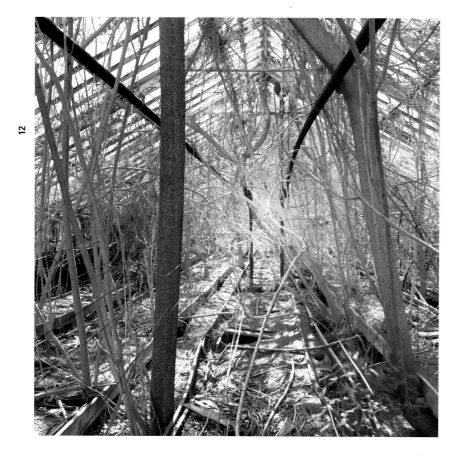

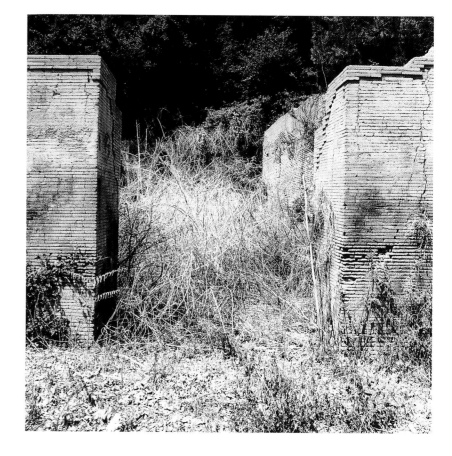

is an invitation. Jodice accepts it at every level; he embraces not only the staggering monumentality, the dynamism, the exhilaration of the city, but also the machinery and the detritus and the dilapidated wastelands which form the background, or in most cases the foreground, out of which rises the renewed urban reality.

It is often the velocity with which the traveler passes through the city that confers upon it a special identity and beauty. So the road, the highway, the expressway, becomes an integral part of the image as it is in Le Corbusier's plans for the "Ville Contemporaine" of 1922. Similarly, as mentioned above, the very machinery responsible for the erection of these roads and the megalithic structures they connect is celebrated by Jodice as it was by El Lissitzky in 1924 in his project for the "Lenin Tribune." Jodice's work abounds in these *hommages* to the masters of early Modernism.

When Jodice does take up a static position within the city, the results are again widely divergent. At times, he invokes the quintessential perspectival *formulae* so dear to artists from Piero della Francesca to Giorgio de Chirico. More frequently, at least in Boston, he reduces the bulk and the three-dimensionality of architecture to a theatrical backdrop, an illusionistic curtain of Palladian motifs. What is most interesting about the latter images is that the artist has magically truncated the aggressive verticality of, for example, Philip Johnson's International Place, completely subverting the architect's original intention to conjure up the urban massing of the medieval Italian hill town, with its arbitrary groupings of vertiginous, at once domestic and defensive, towers. In the same image, the post-modern architect's glib proliferation of flattened Palladian forms is re-edited and redeemed by the photographer's civilizing lens.

Turning to Jodice's interiors reveals an even greater diversity of outlook. In many photographs, the well-documented strain of romanticism that draws the artist to empty, shrouded spaces and their draped or covered contents finds ample room for indulgence; the results are haunting images of soft, undulating lights and darks in an atmosphere exempt from time. Equally enigmatic, if technically very different, is the crisp definition of his treatment of architectural

interiors such as those at the John F. Kennedy Library. In this building, I.M. Pei's paean to the Modernist love of glass, Jodice eschews the dramatic airiness of the main celebratory space, opting instead for the tightly controlled, hermetic ambience of the windowless, wood-paneled chamber. Windowless? Jodice's eye takes in a number of tantalizing openings in the grid, one a glazed panel through which we observe a world far more remote than our own, specifically, the lunar landscape, with its "slant of light" and its solitary human figure. Thus our Virgilian guide leads us back in time to one of the defining and transcendent moments of human history.

There is a contradictory tendency in many of Jodice's ostensibly architectural views to block or negate our entry into the space. So, for example, his image of the abandoned greenhouse in Sudbury echoes earlier photographs by the artist in its overall composition: the gnarled branches smashing through the roof of the derelict building and crowding into the foreground are akin to the knotty trunks guarding the wall at Arles, or the vegetation gone wild in the empty cloister of Suor Orsola. For Jodice, plant life often shares the destructive vitality of the serpent dragging Laocöon to his doom. There is, moreover, in the Sudbury image, a masterfully rendered conflict between the inevitable pull of the perspective and the physical impossibility of penetration. In the end, the viewer becomes both seer and seeker, perpetually enmeshed with the artist in a fabled quest for the seemingly dormant but still active and formidable beauty of nature.

The Human Figure
When, perhaps against his inclinations, Jodice shifts his attention to the interaction between architecture and those who create and inhabit it, the outcome is eye-opening. Characteristically – and this is confirmed by his recent European work as well – Jodice assiduously avoids the living human figure in his architectural views. In keeping with his attraction to the museum display and the diorama, the most populated of his photographs in this exhibition is that of the vacant lot in East Cambridge. Here, effectively turning his back on the very real individuals whose activities make up the nearby riverside scene, he

14

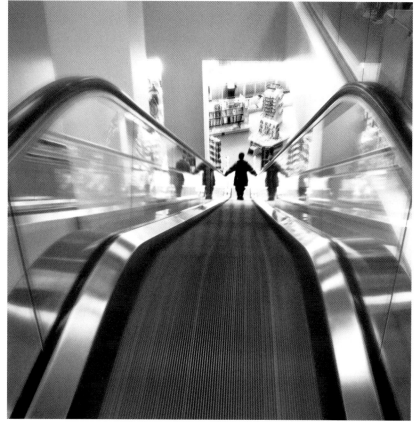

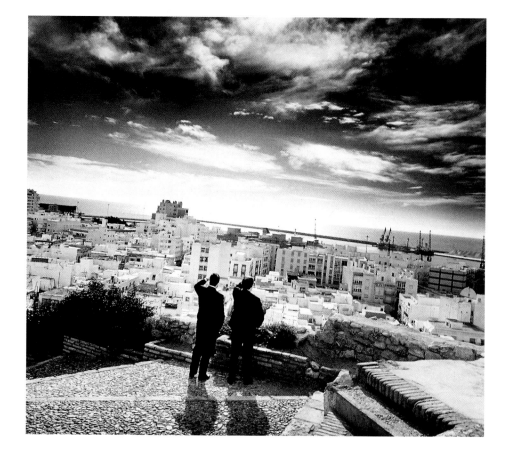

focuses instead on the imposing mural which purports to mimic that scene, complete with its painted sailboats and *boulevardiers*. In short, the actual is renounced for the illusory. Along the same lines, but even more pointedly, when he photographs French's iconic Minute Man statue in Concord, the Minute Man disappears. And on those ever rarer occasions when he does allow the presence of living human participants in the urban milieu (only five photographs from the Boston series include living figures), they are invariably isolated, either reduced to mere silhouettes by their distance from the viewer, or absorbed into a larger architectural pattern, ambiguously spanning the image like a string of paper dolls.

If Jodice is ambivalent in his attitude toward the explicit inclusion of the living figure, he is nevertheless preoccupied with its representation in art, especially when that representation is viewed across the gulf of time. He is always drawn inexorably to the most compelling remnants of the classical world. Likewise, in Boston, he exercises his uncanny ability to find and revive the protagonists of ancient Mediterranean culture. Though most of these beings have lost their identities, and many have lost their limbs, their lips, their eyes, nevertheless they all share what the Italians would call *disponibilità*, a willingness, in this case to communicate with and through the photographer. At the Isabella Stewart Gardner Museum, for instance, Jodice raises up from an apparent bonfire of foliage an ancient orgiastic dance, the individual participants in which embrace or leer or are absorbed in melancholy isolation. A masterpiece of this genre is the photographer's interpretation of a Roman bust in the Wellesley College art museum.

From the late Imperial era, the head-and-shoulders sculpture of a little boy in a toga seems at first glance just another of the innumerable fragments of a long-dead culture scattered throughout the world's museums. It is the delicacy and the sensitivity of Jodice's approach – his literal approach in the sense of his physical placement before the object – that reanimates the figure. What emerges from this encounter is a collaboration between artist and artefact. The child, heretofore transfixed and inscrutable, is momentarily freed to consider

us against the infinite vista of history, and to compare our vulnerable flesh and limited span to his enduring presence in stone.

If we turn to those photographs in which there is no overt human presence, we discover that such a presence nevertheless lurks behind all organic forms. Both the trunks of trees and the shadows they cast suggest willful, anthropomorphic forces. Moreover, there are often dialogues to be discerned between the various natural components of these outdoor images, dialogues dependent above all on the sharp contrast of light and shade. Aggressively sculptural trees extend their luminous roots into the dark earth, while the silhouettes of their branches stretch even further across the late afternoon landscape.

Vines and tendrils recur as an important anthropomorphic motif in many of these images as well, often in conjunction with man-made decorative elements. Jodice finds himself drawn to one such juxtaposition in the eighteenth-century ambience of the Codman House in Lincoln. Here, a mass of vines has attached itself to a solitary column marking the rising boundary of the formal garden. The column itself is, *a priori*, an historically sanctioned allusion to the human figure, as illustrated by an endless succession of anthropomorphic interpretations which are the primary subject of a book by one of Jodice's most eloquent commentators, George Hersey (*The Lost Meaning of Classical Architecture*). In effect, Jodice's photograph is a sophisticated if somewhat surreal variation on the origins of the Corinthian column as described by Vitruvius, at the same time that it alludes to explicitly human imagery in the photographer's earlier work.

Place and Time
One day, making his way across Boston Common, a teenaged Robert Frost noted that «the walks were all fresh-black'd with rain.» Visual thinking is an inherent quality of great poetry, and clarity of vision and conciseness of expression are likewise qualities to be found in great visual art. And so we discover a point of contact, an affinity, however unexpected, between New England's favorite "regionalist" poet and the Neapolitan photographer, Mimmo Jodice.

The question of regionalism is in fact an interesting and important one. What, after all, is

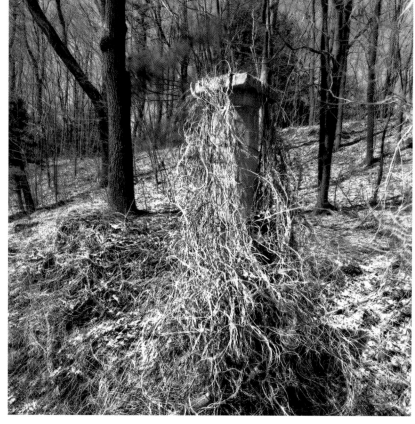

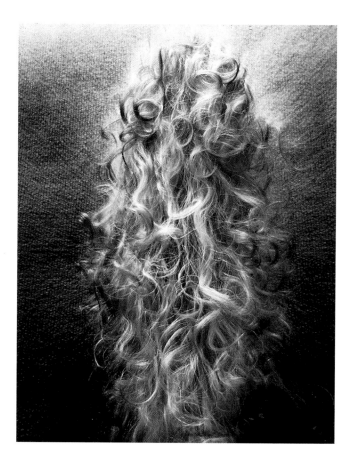

Jodice doing in Boston that he cannot do elsewhere? Are these photographs really "of" Boston? One of the dominant myths of contemporary life is the myth of globality. Jodice does not shy away from illustrating this phenomenon. For example, among his Charlestown views is a disquieting industrial landscape with a glowing hemispherical tank. This is a summary image in the sense that it is at once architectural and anthropomorphic. It is also, with its aura of the desert, a denial of its actual locale, the port city of Boston. We could be anywhere – in Saudia Arabia, the outskirts of Athens, industrial Manchester, the moon. The modernity of Boston, its placelessness, is expertly thrown into relief.

But more often than not, Jodice accepts the larger challenge, and follows the quest for the most local truth. Here it is natural to return to the photograph taken at the Minute Man National Historical Park in Concord, a hallowed site in New England and American history. Artfully calling our attention to the seemingly unremarkable side of the statue's base is Jodice's way of contributing new meaning to historical narrative. With its uncarved and pitted stone slab surrounded by bedraggled, windblown wreaths of artificial flowers, Jodice's image is a memorial to the monument itself, and to the emotions – patriotism, nostalgia, respect for the dead – of those who erected and revere it. So he *is* a New England artist when he is in New England, confronting and redefining the reality of its great littoral capital and of the innumerable quieter worlds that are its inland domain.

In what is surely the most famous and evocative description of Boston to date, T.S. Eliot's solitary man wanders the city's half-deserted streets, his head filled with memories and contradictory speculations and dreams. He is always near the water. He hears the mermaids singing, long before he sees them, if he ever does. Mimmo Jodice is on their trail.

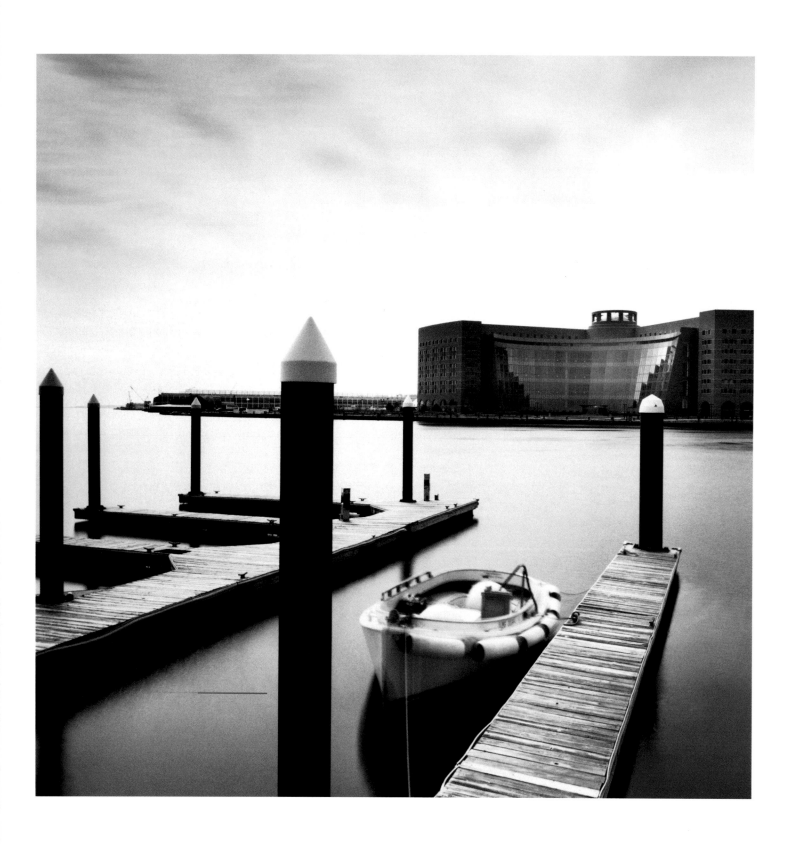

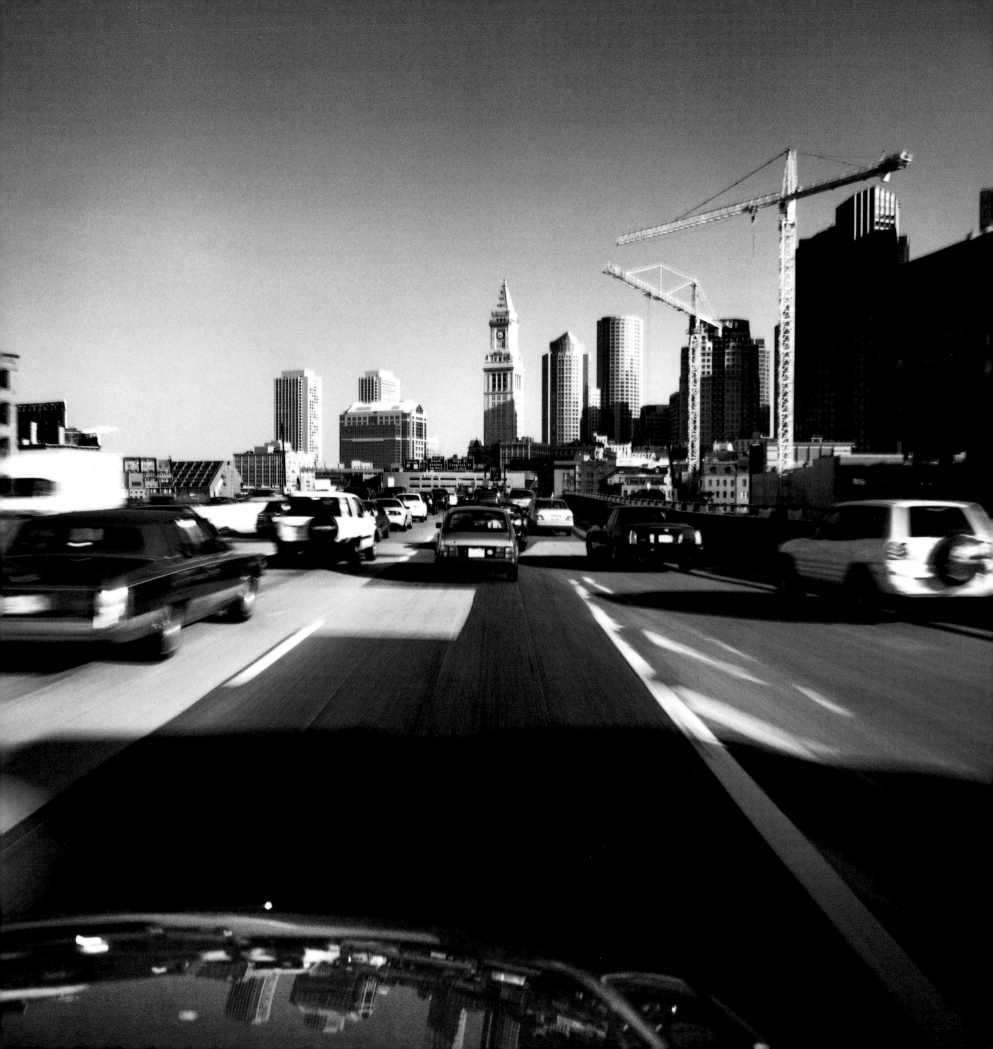

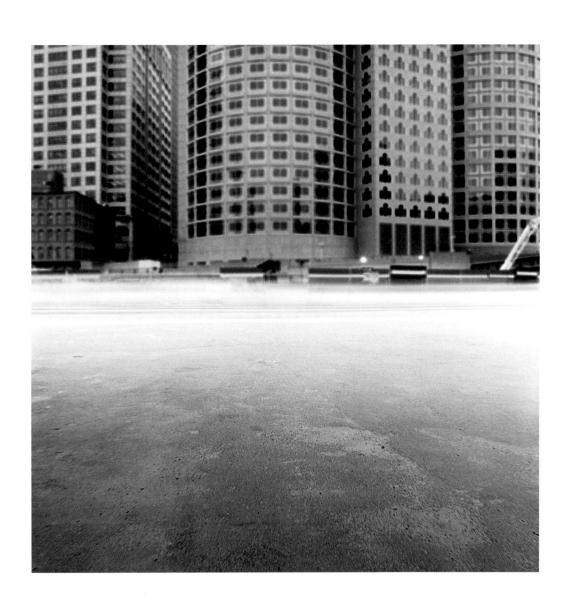

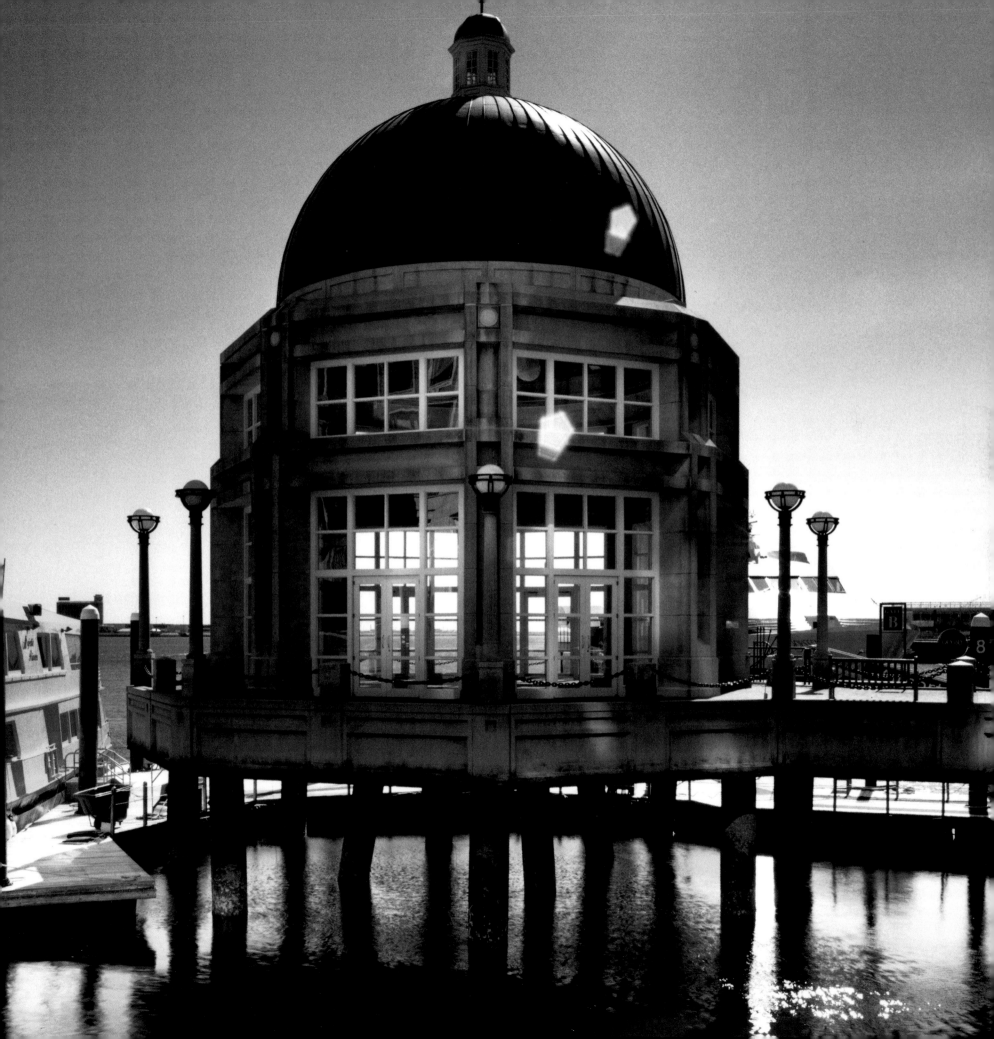

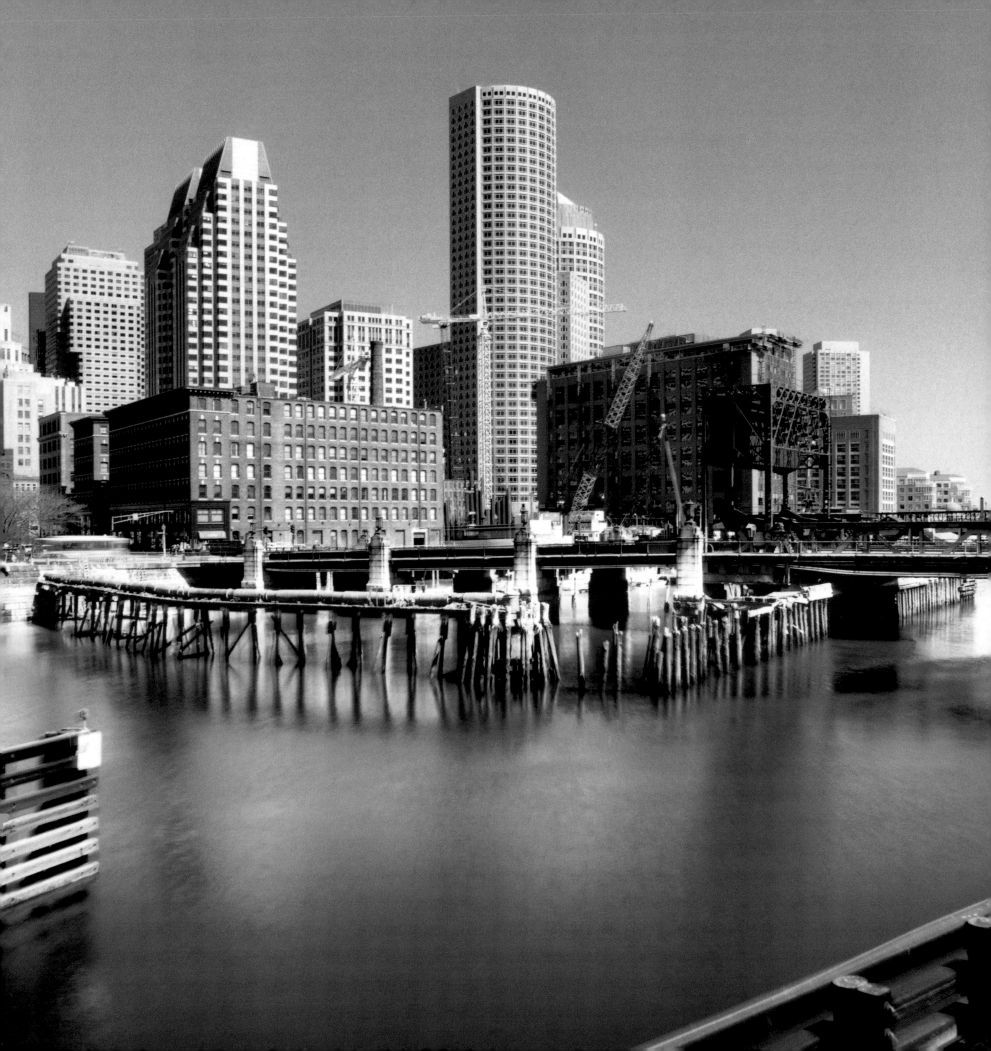

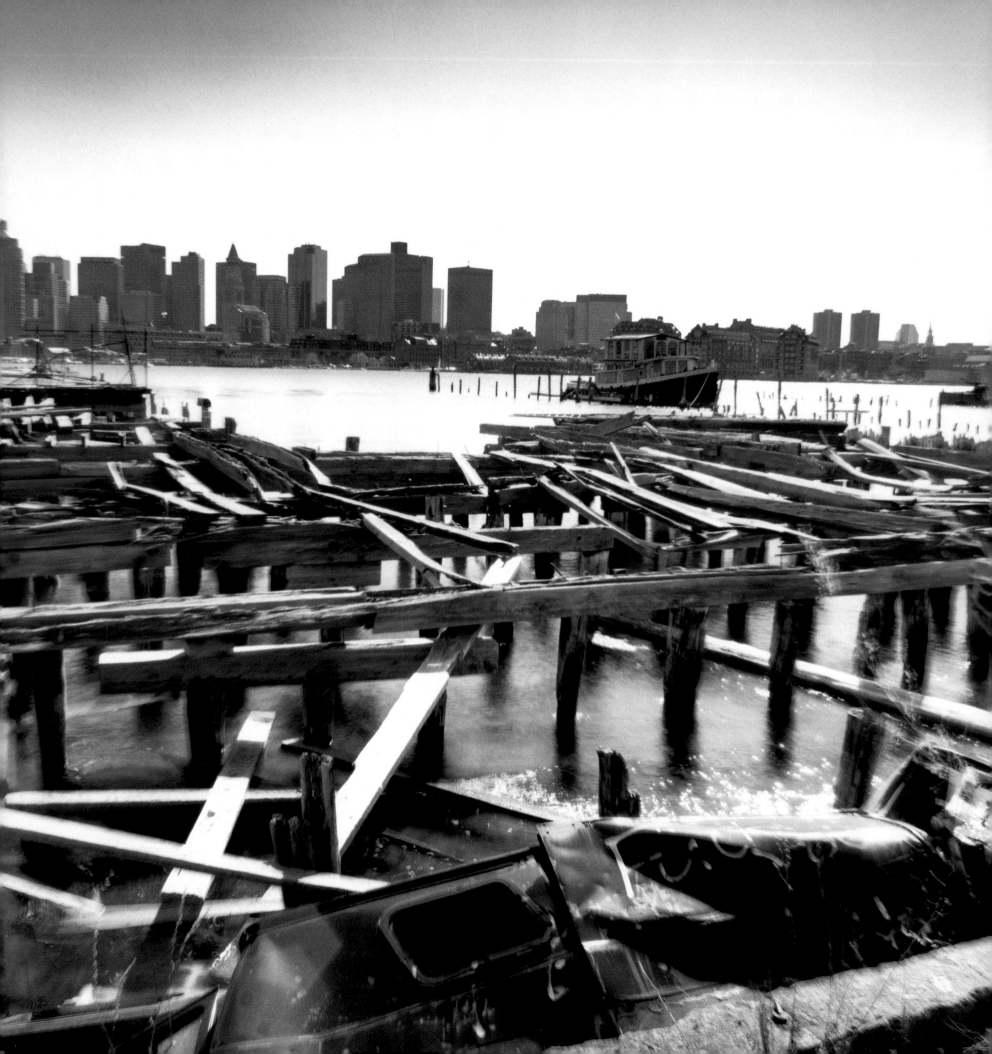

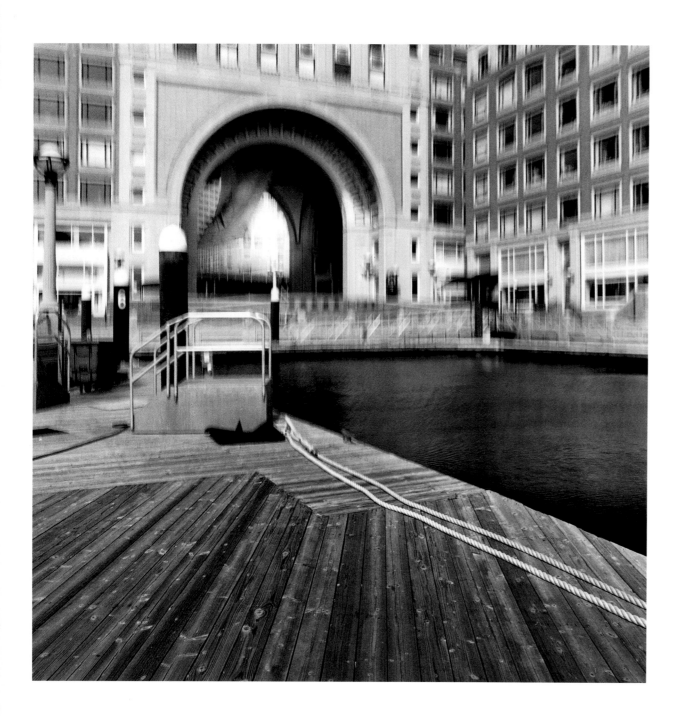

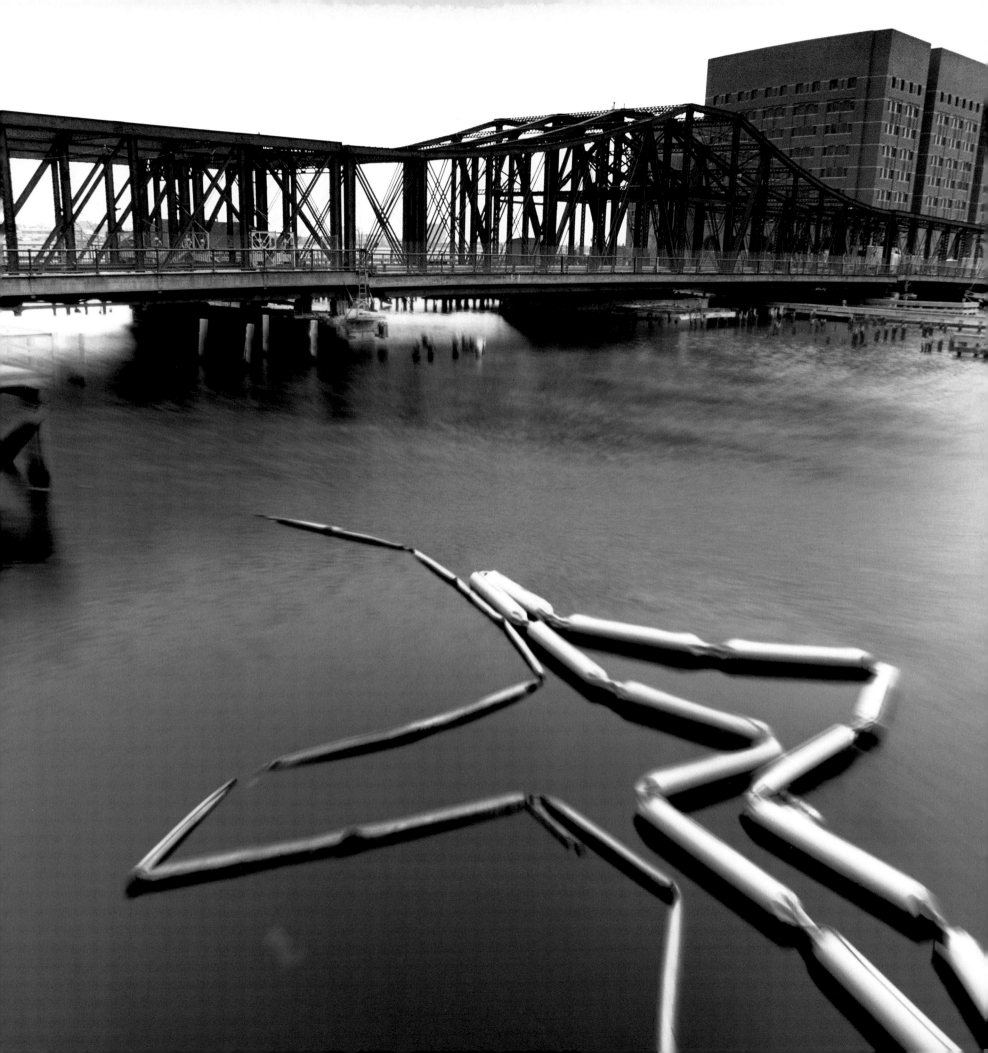

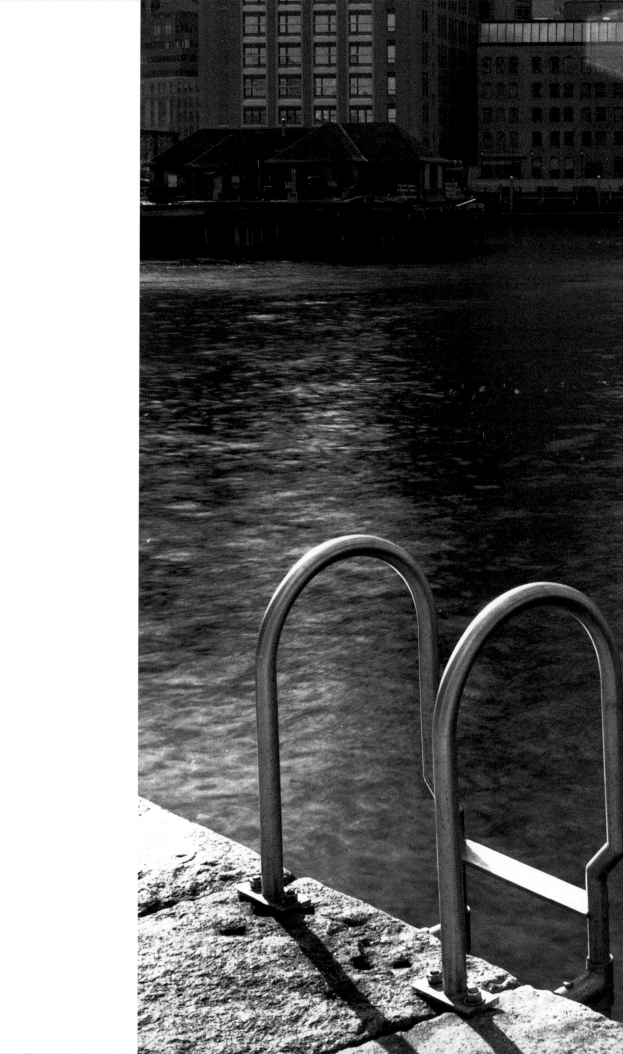

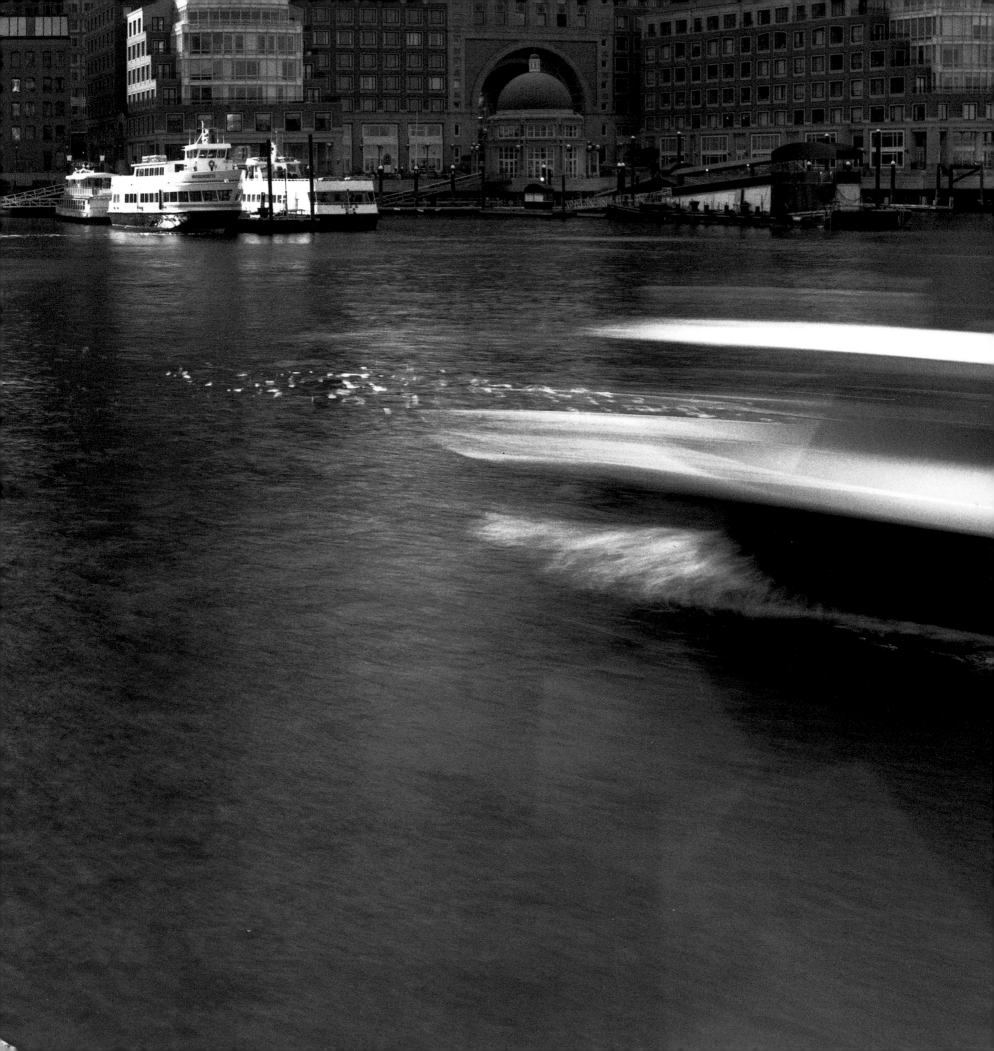

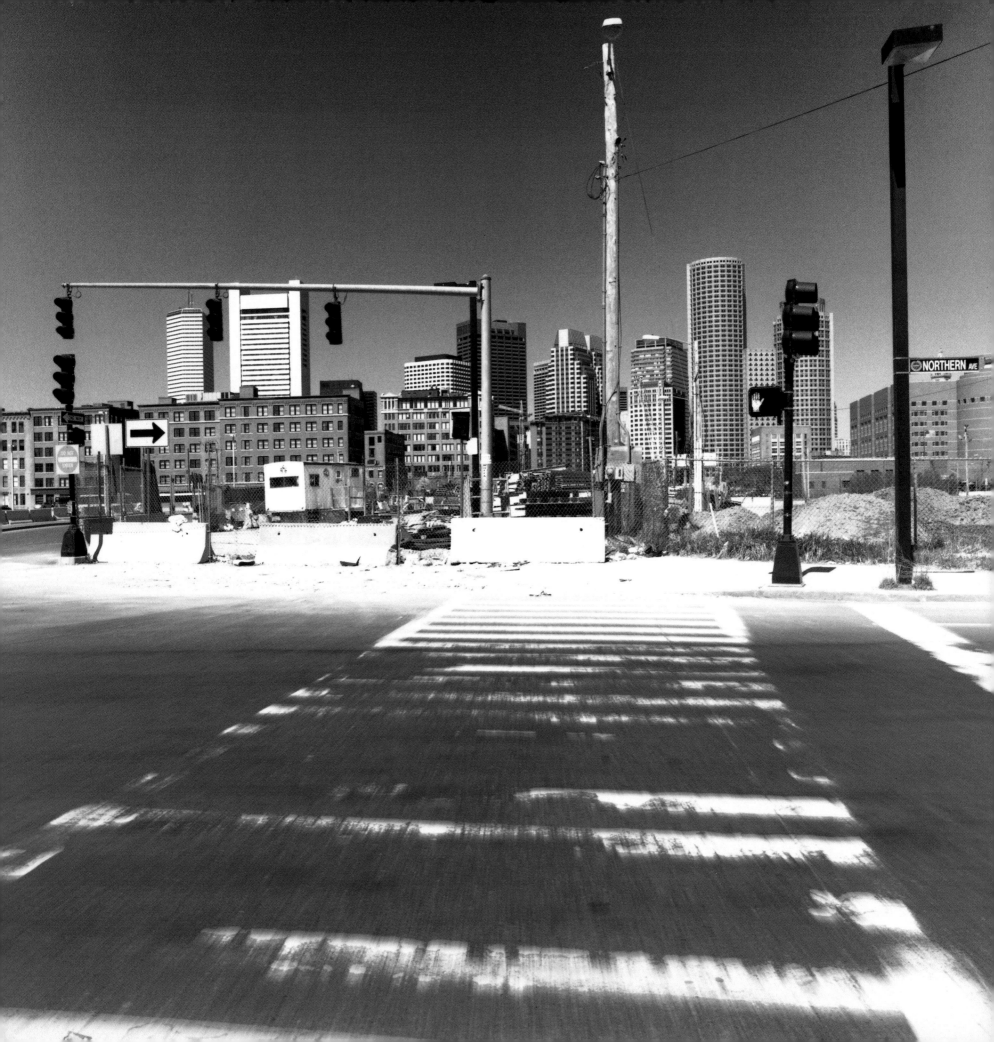

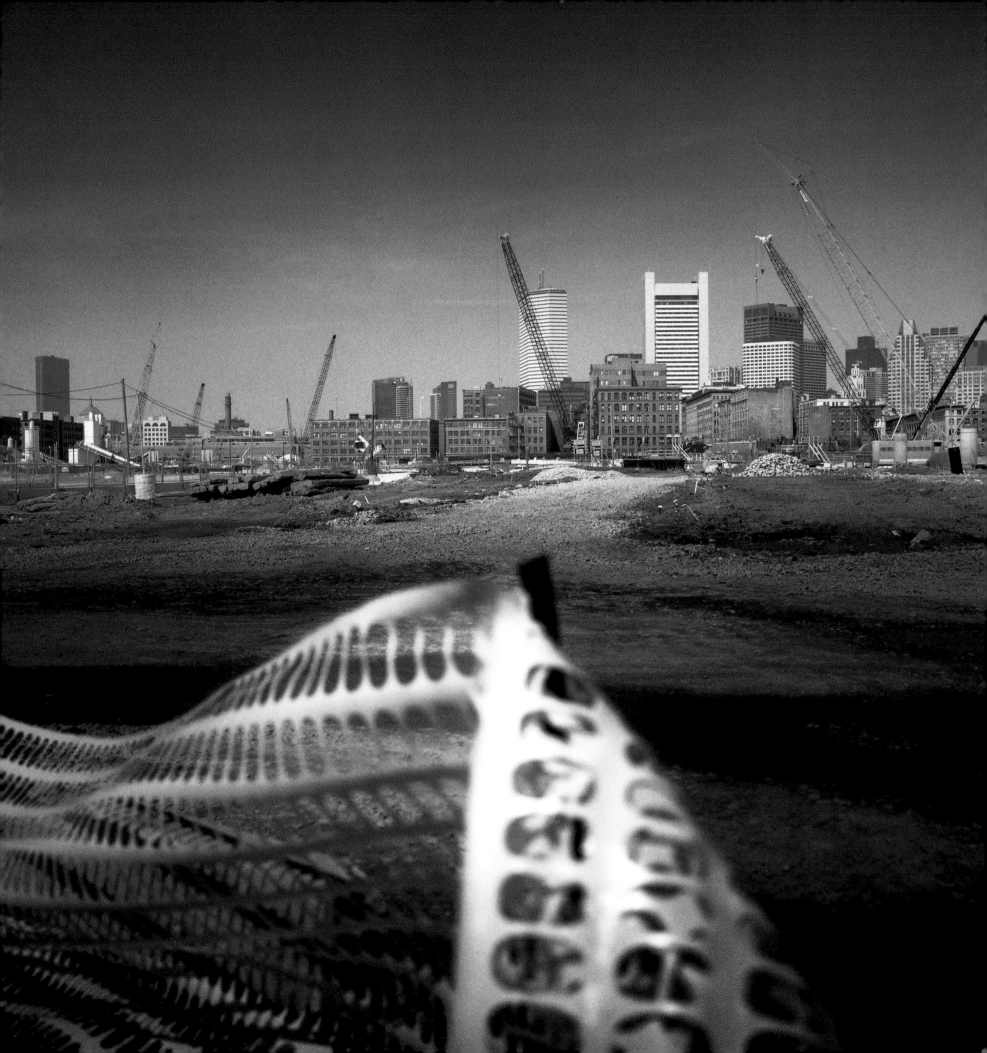

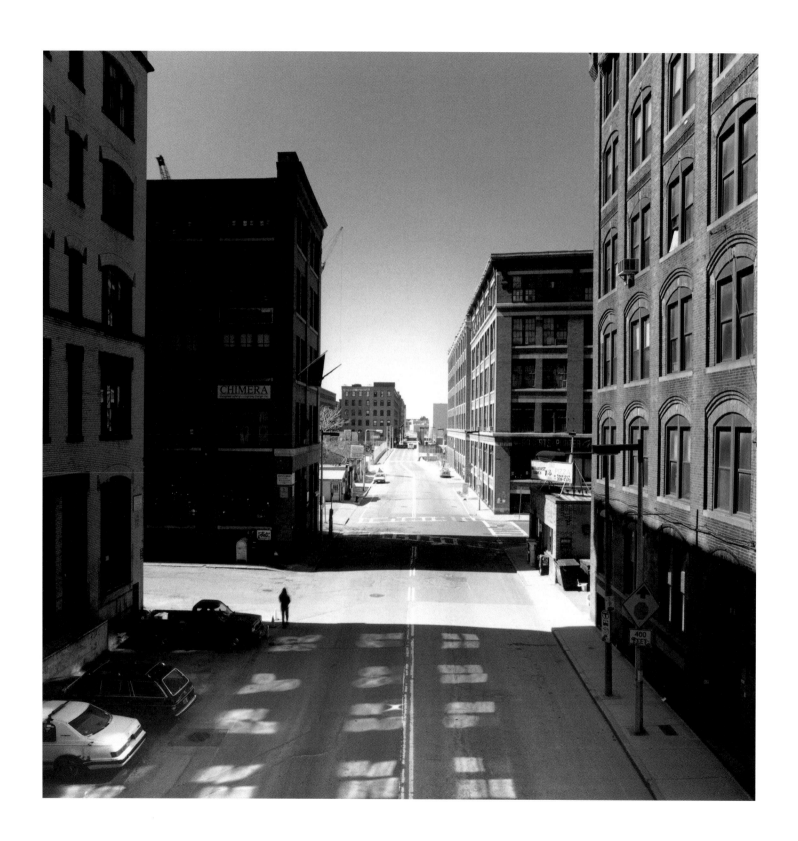

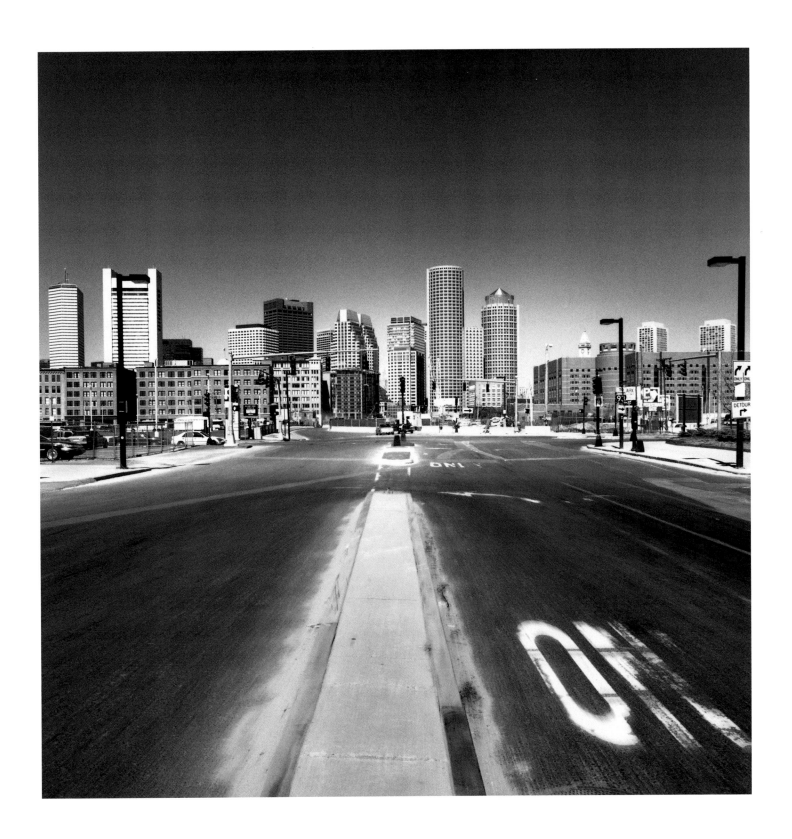

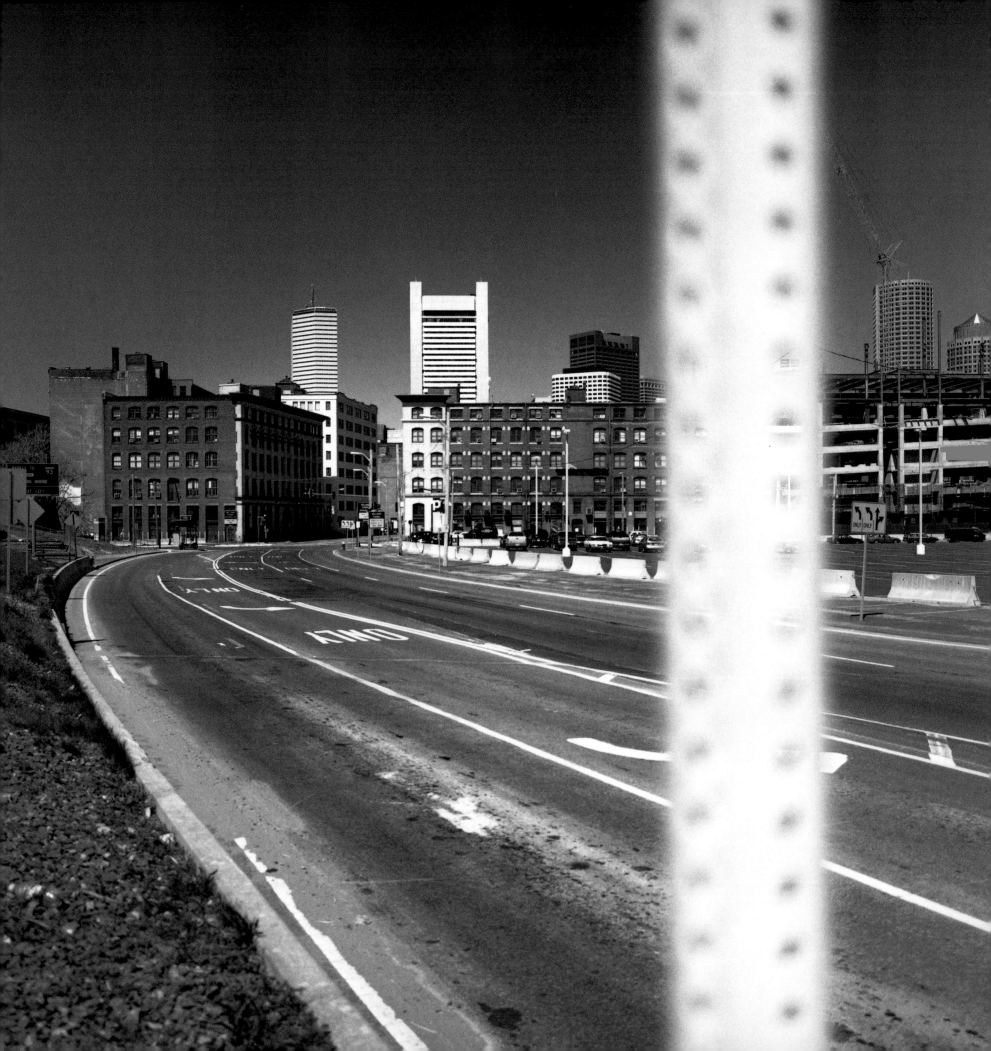

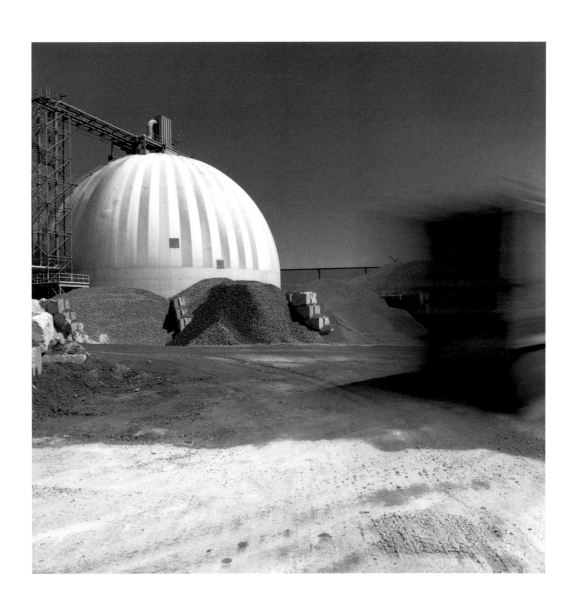

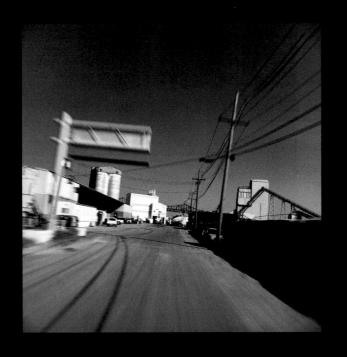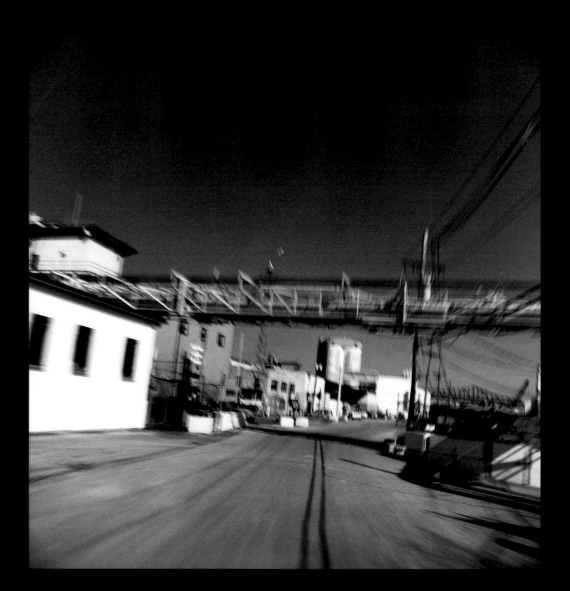

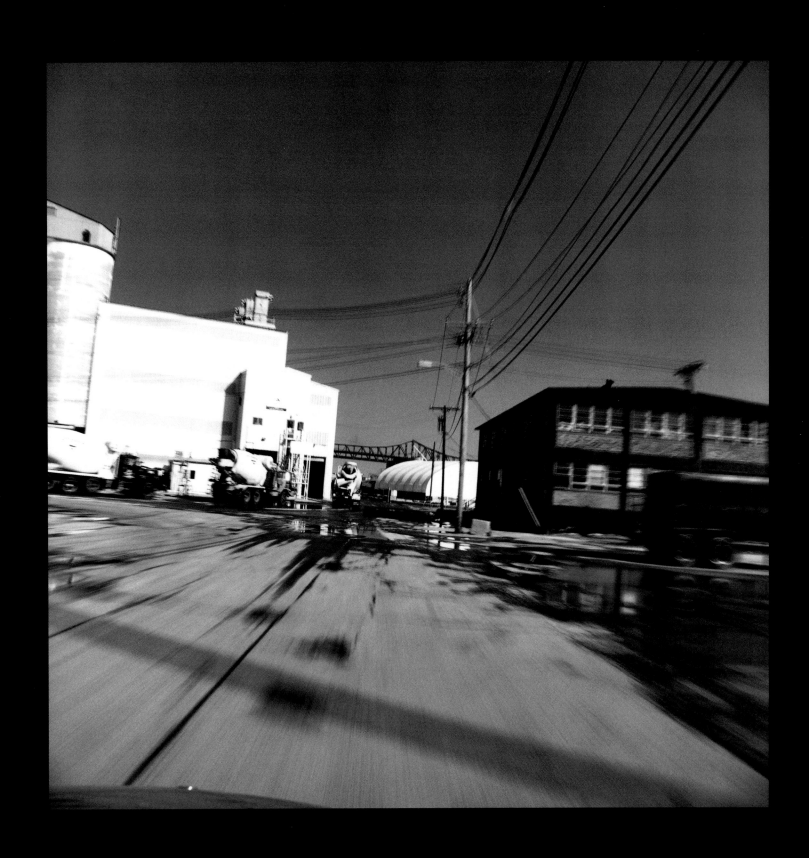

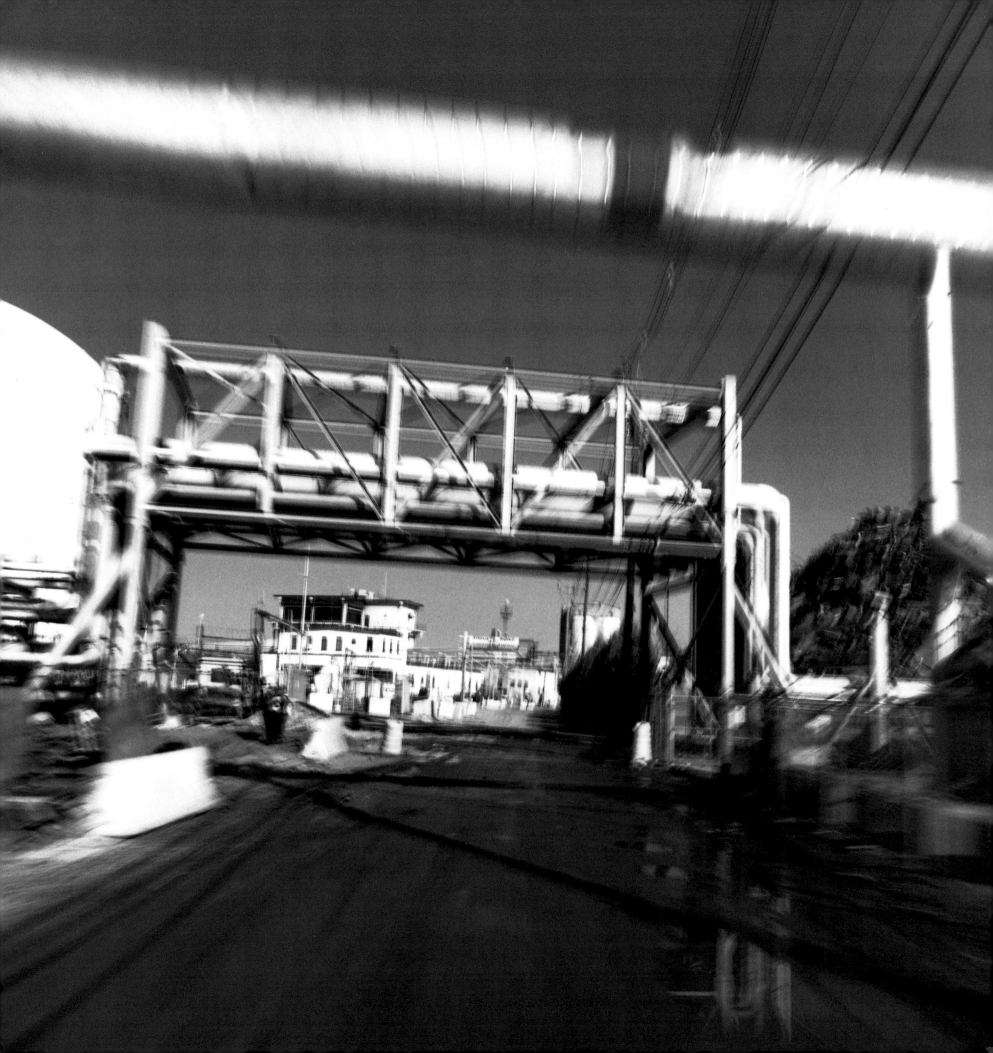

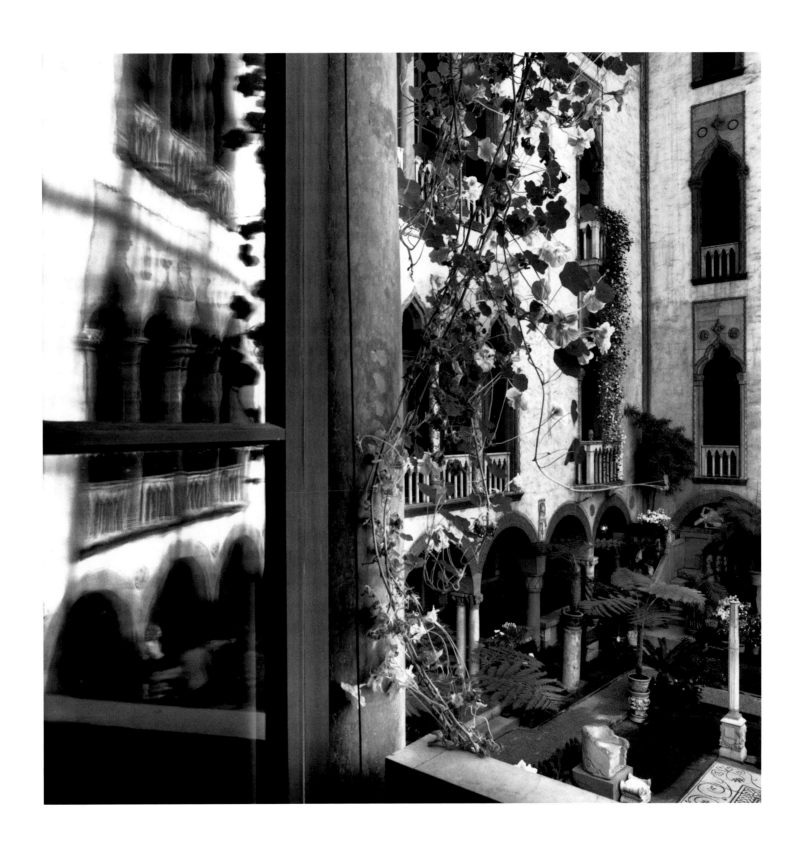

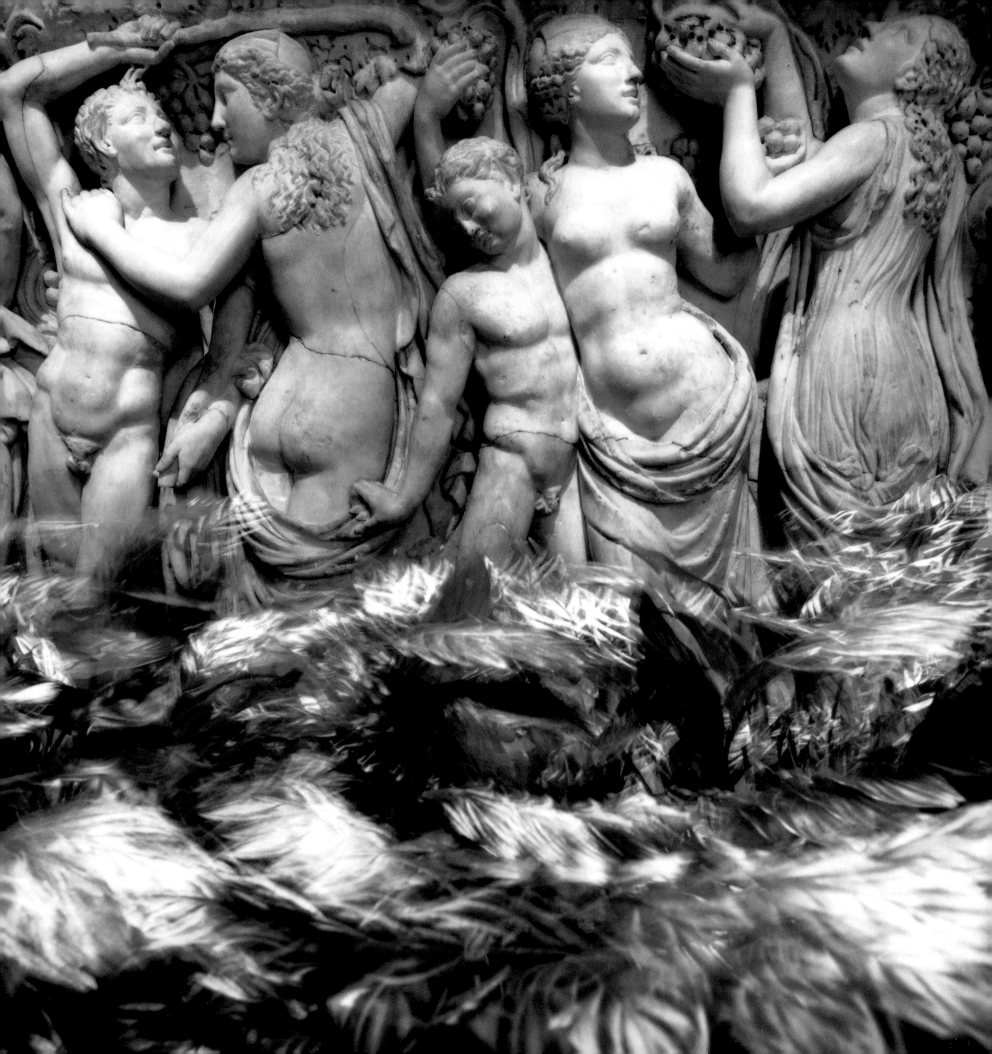

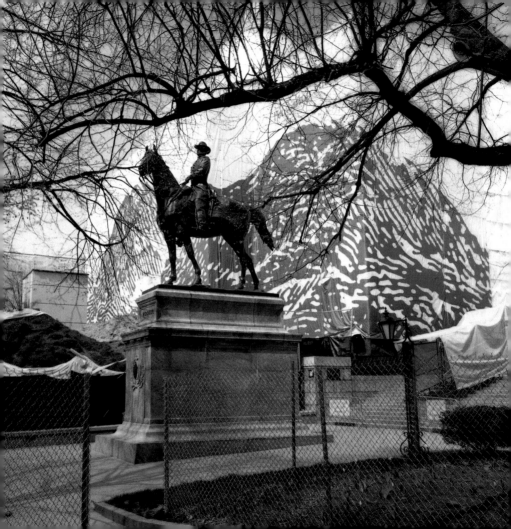

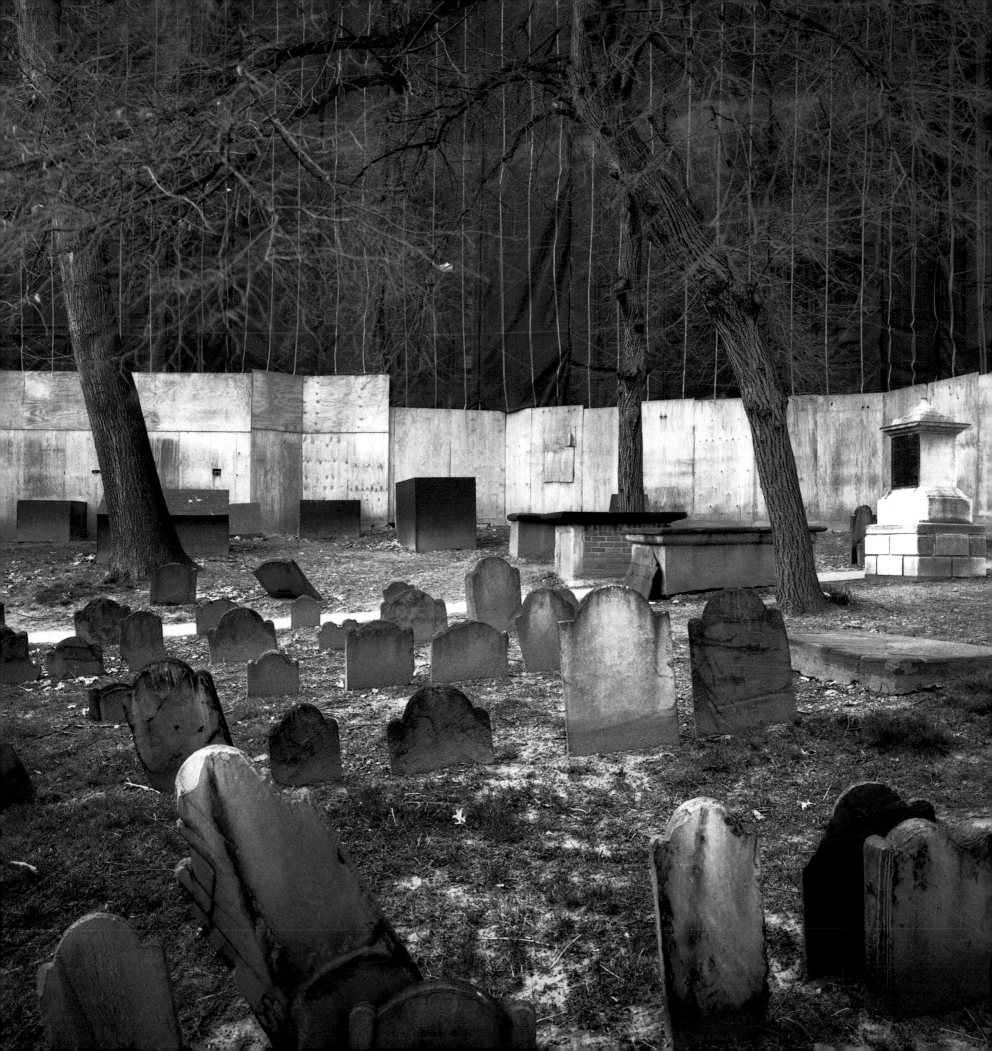

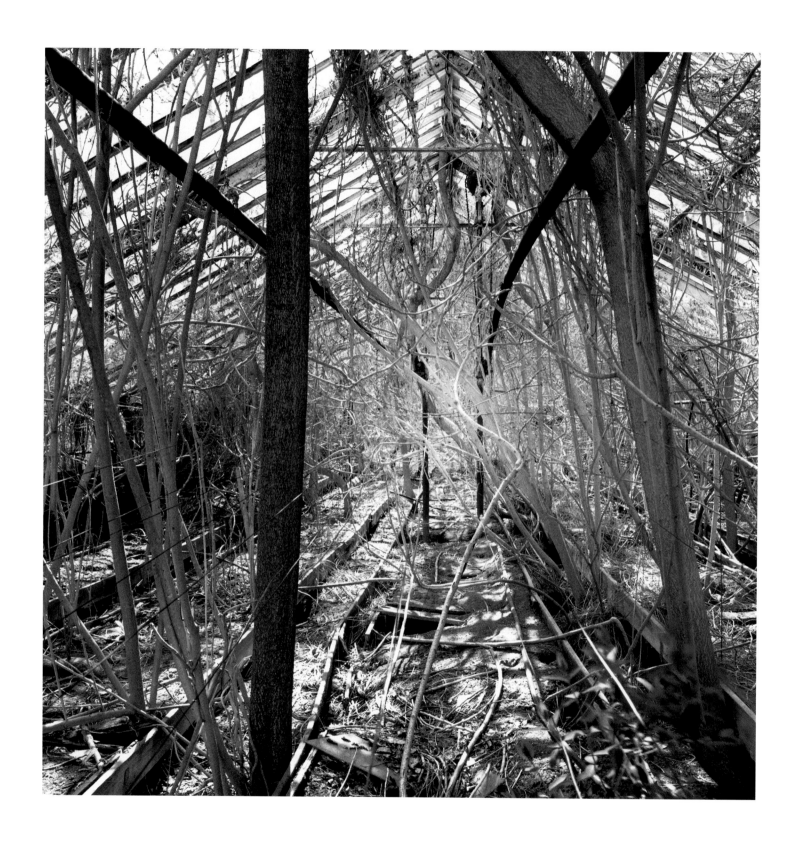

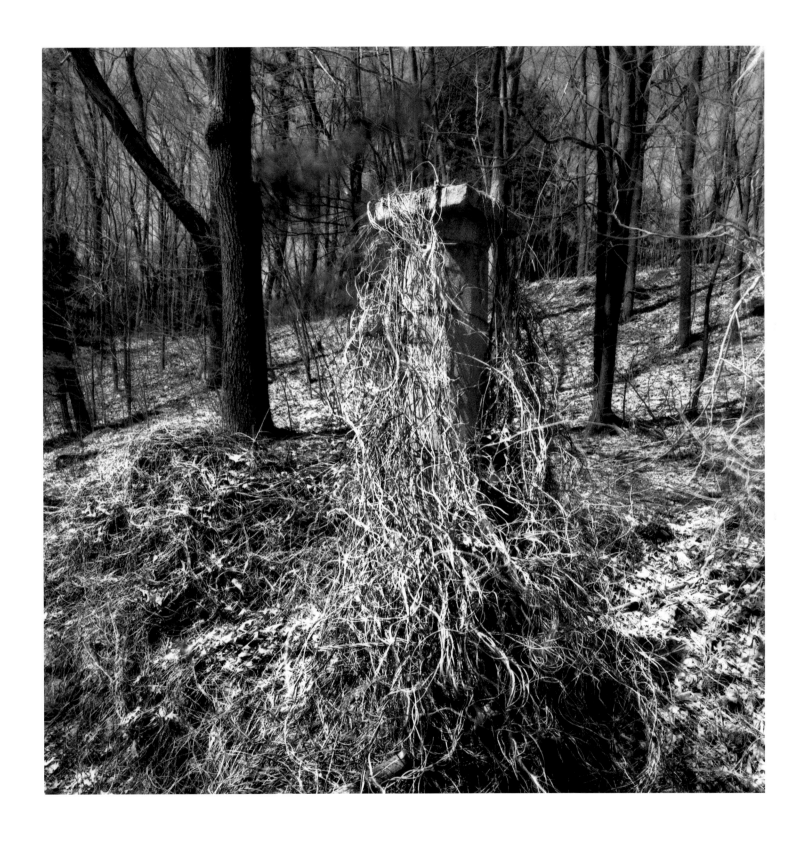

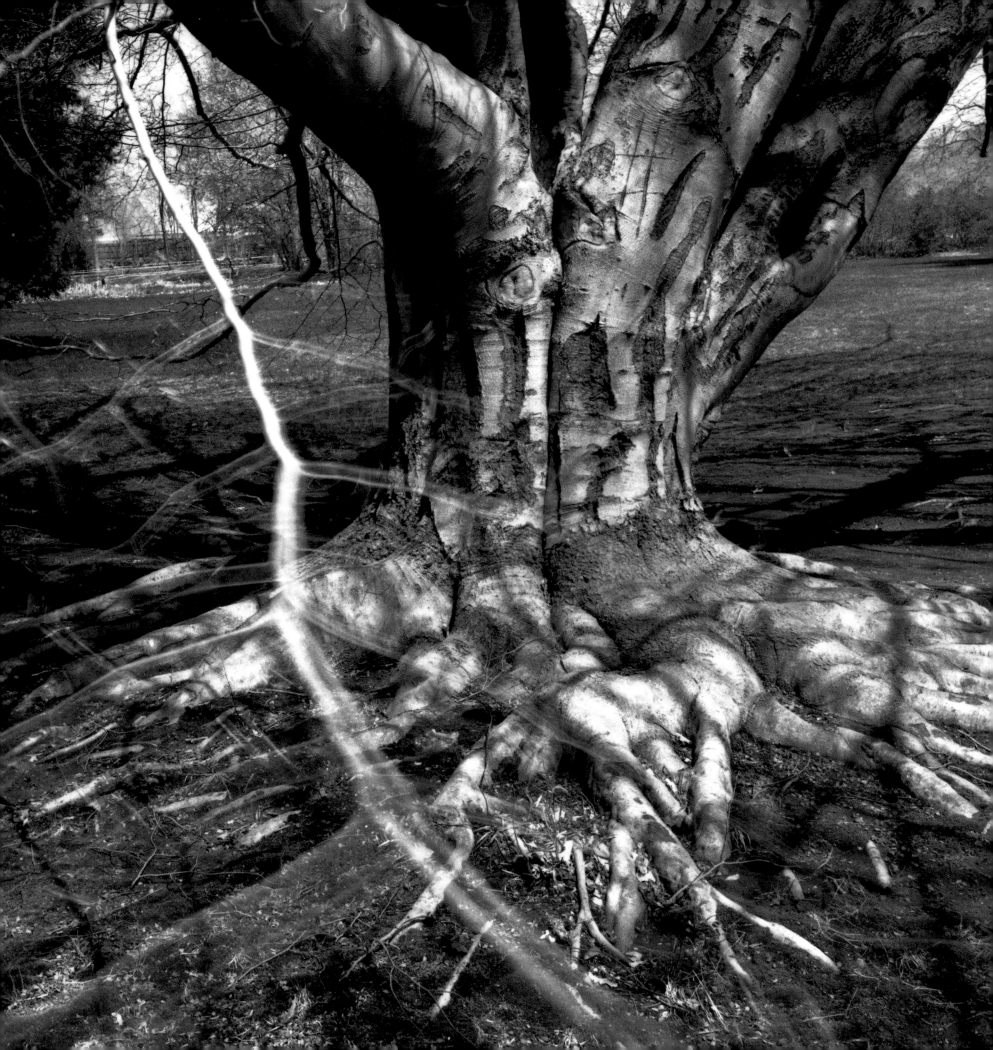

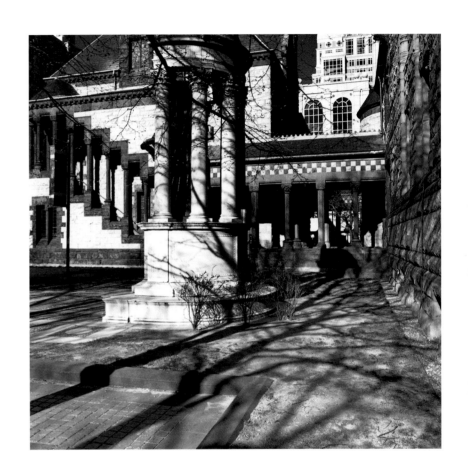

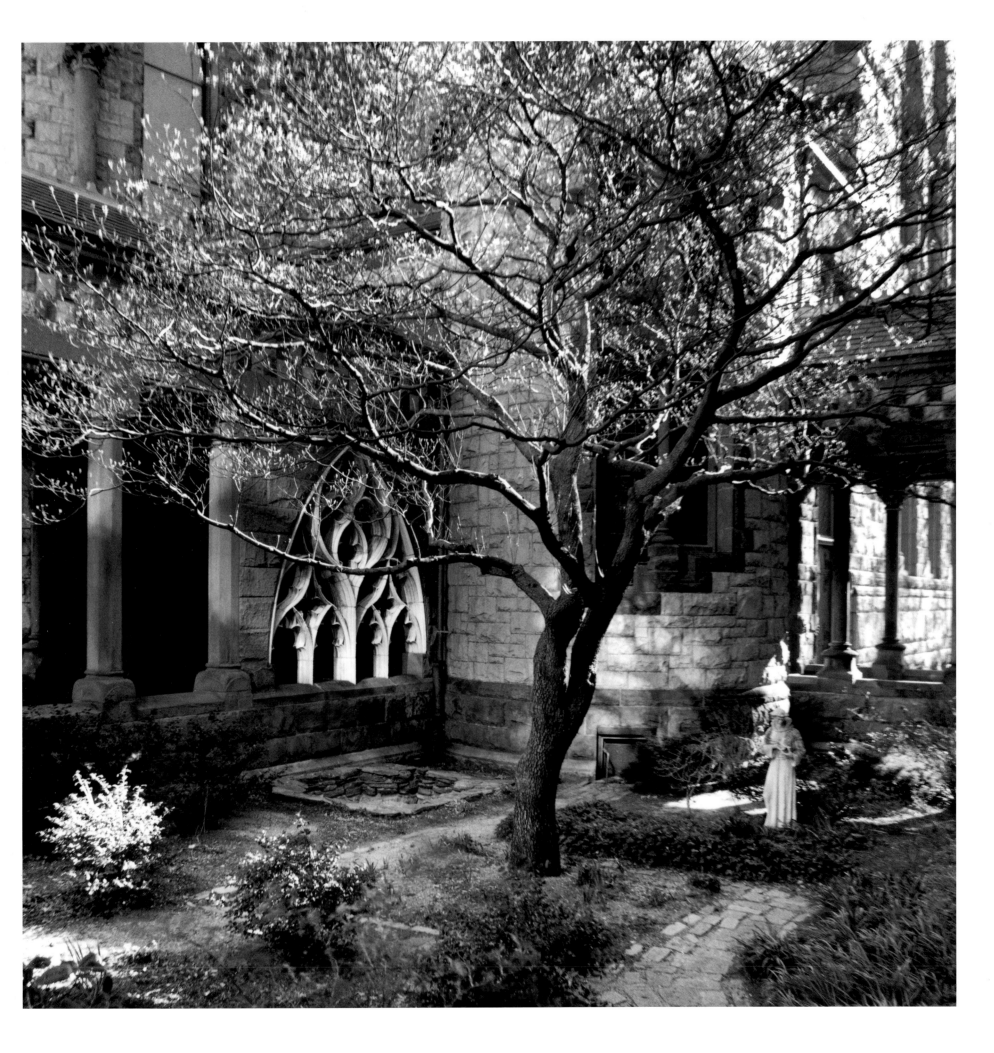

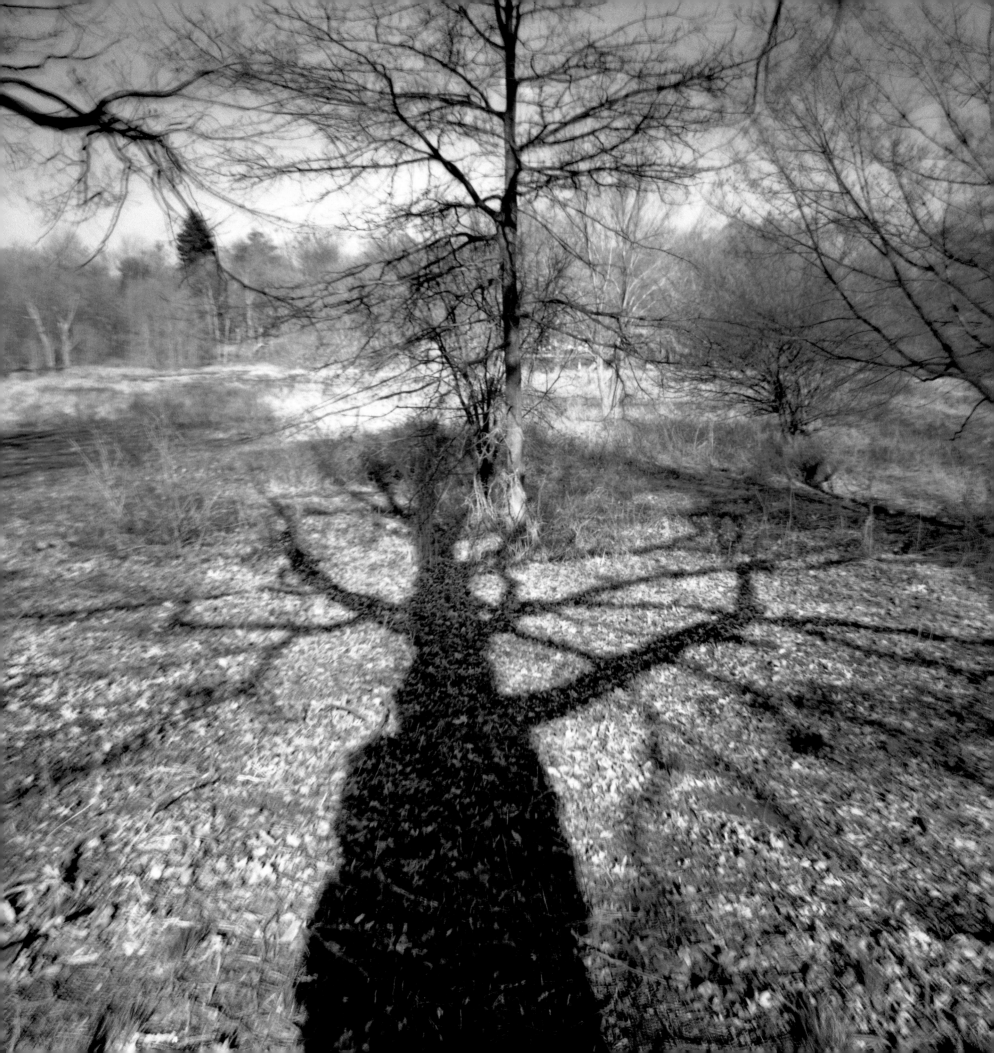

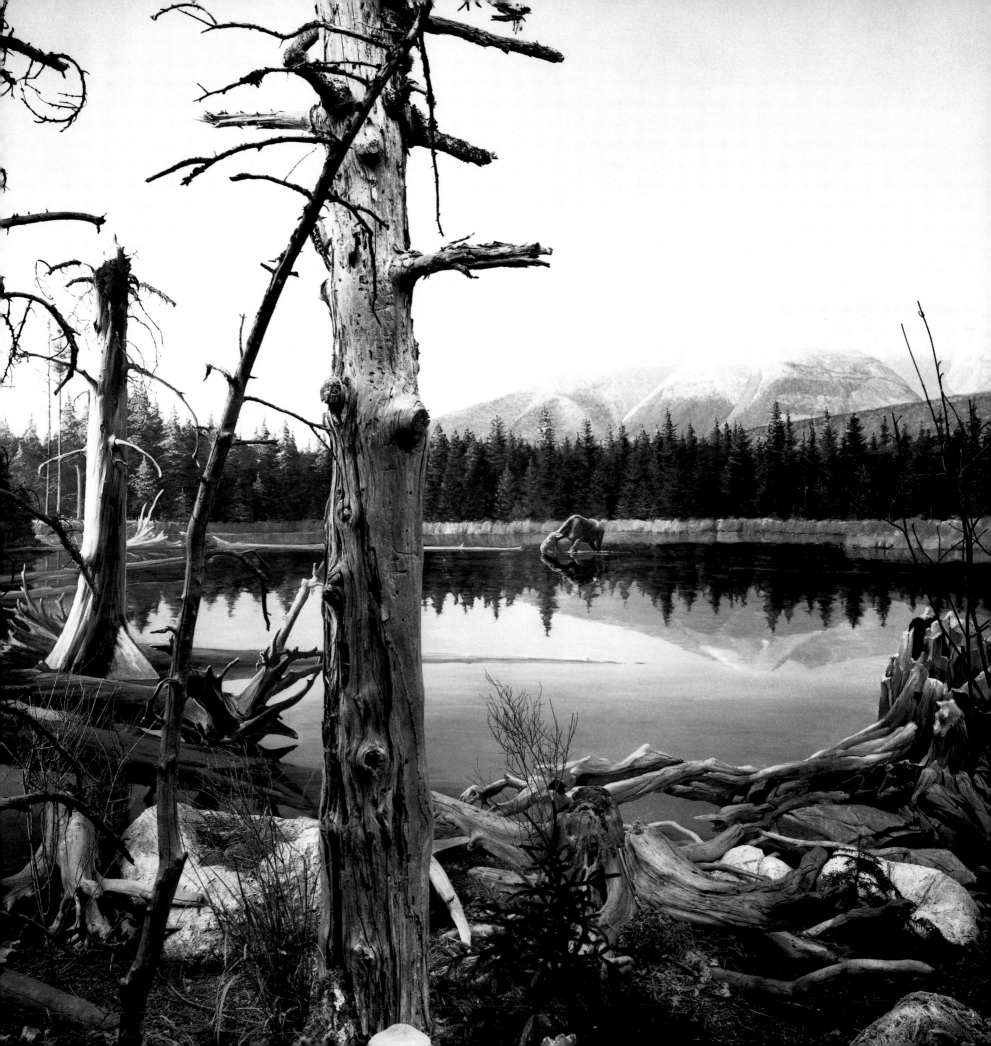

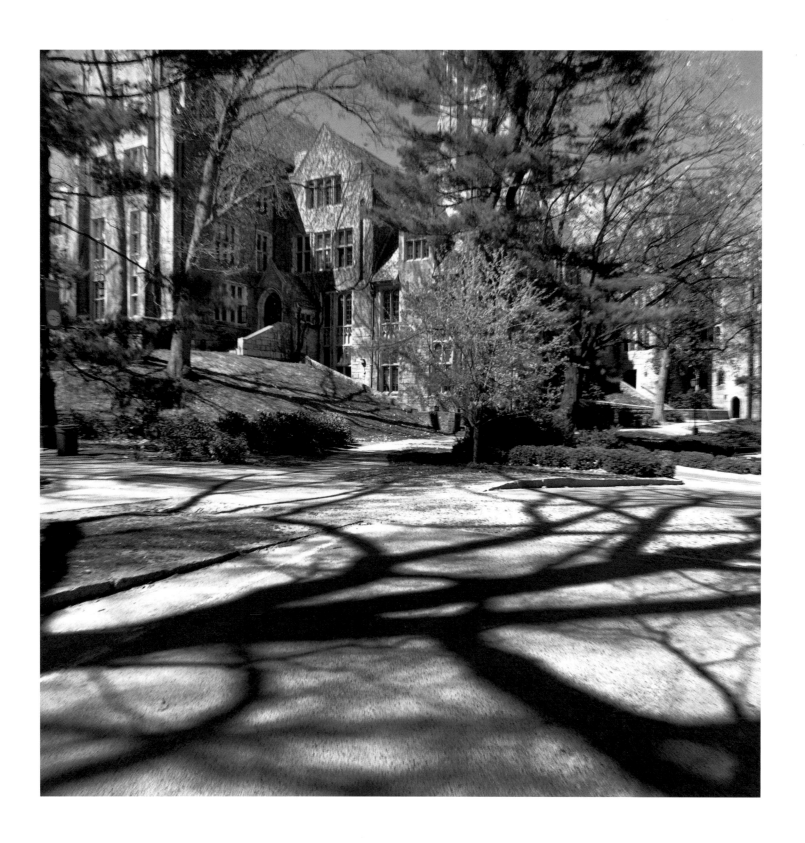

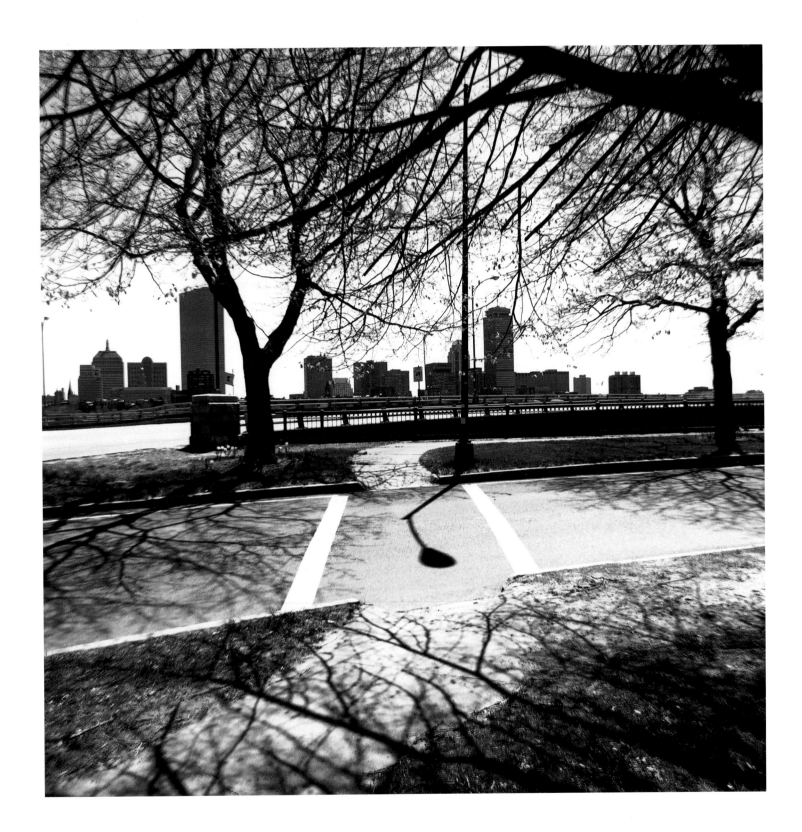

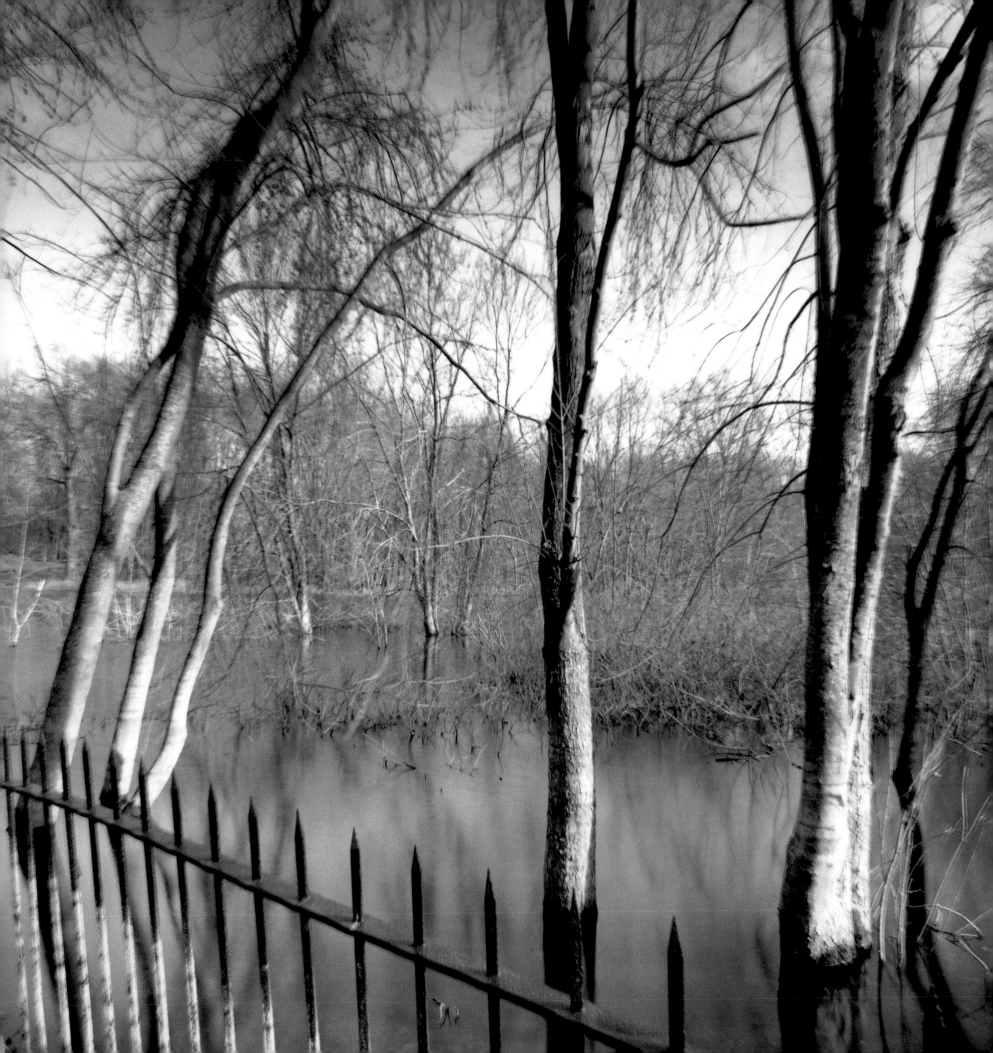

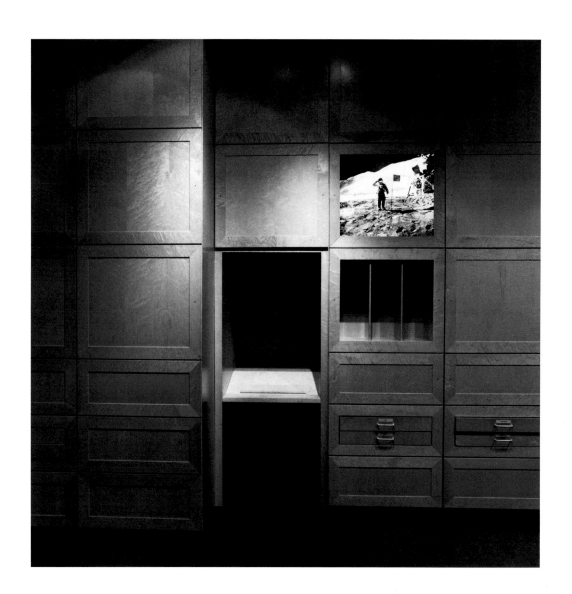

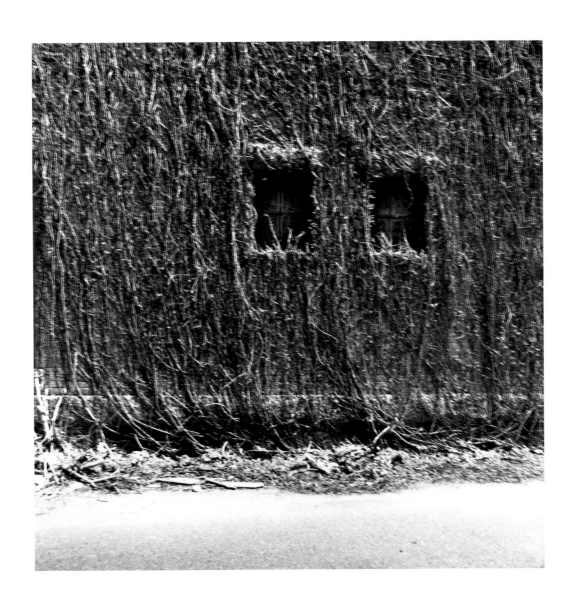

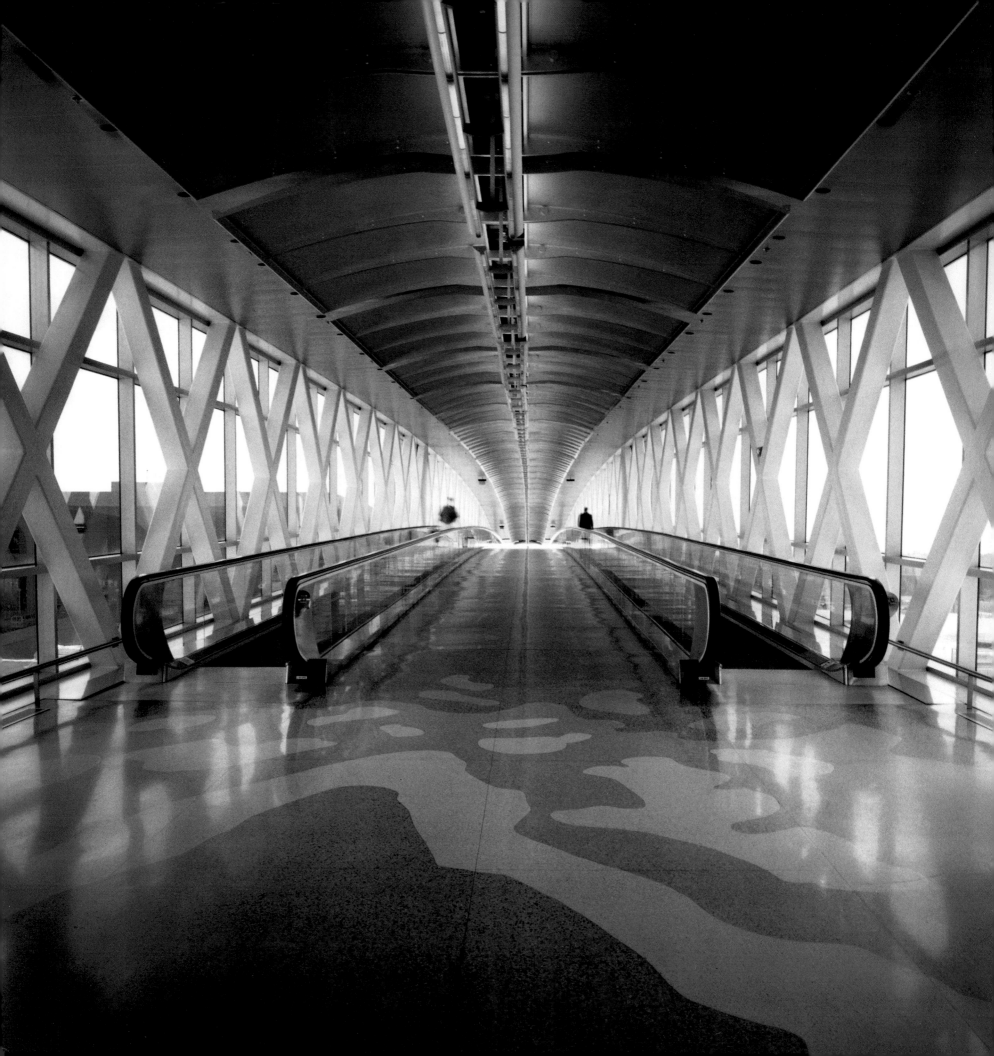

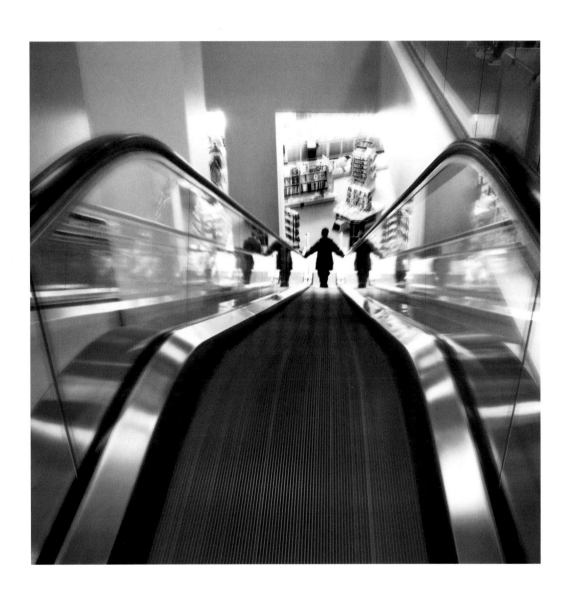

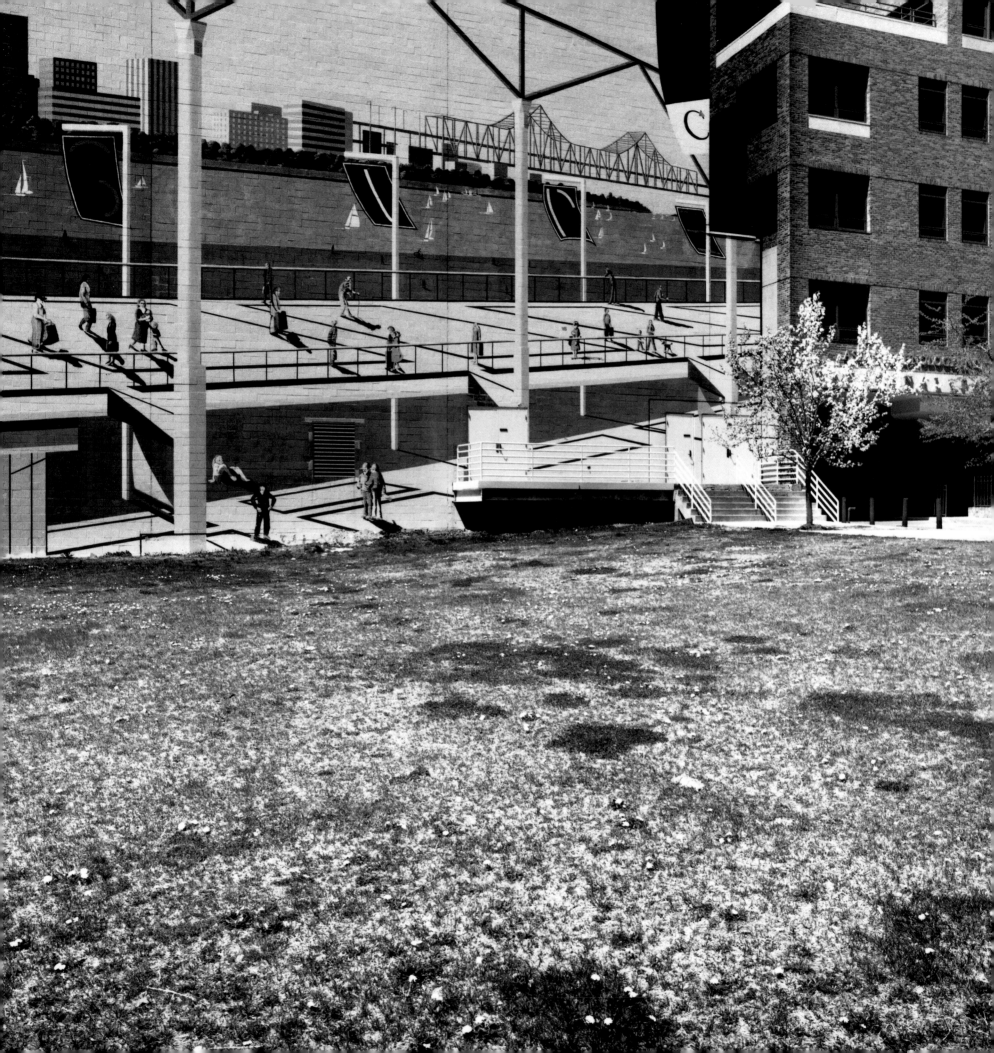

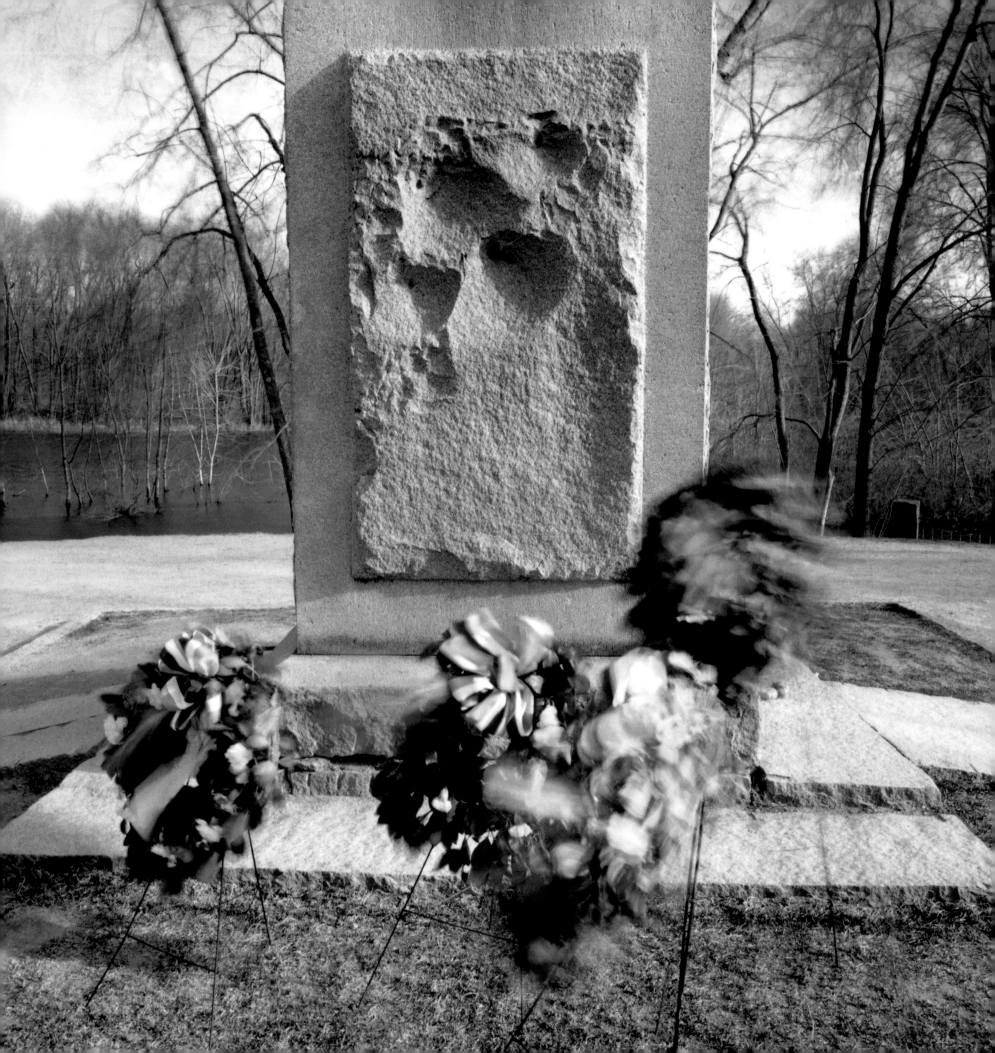

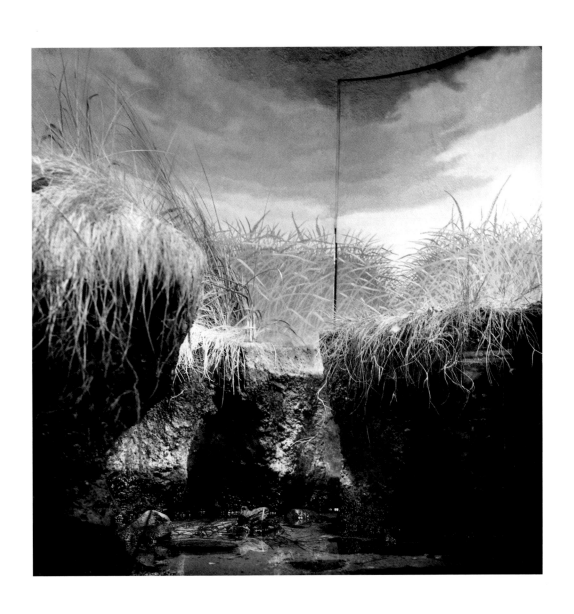

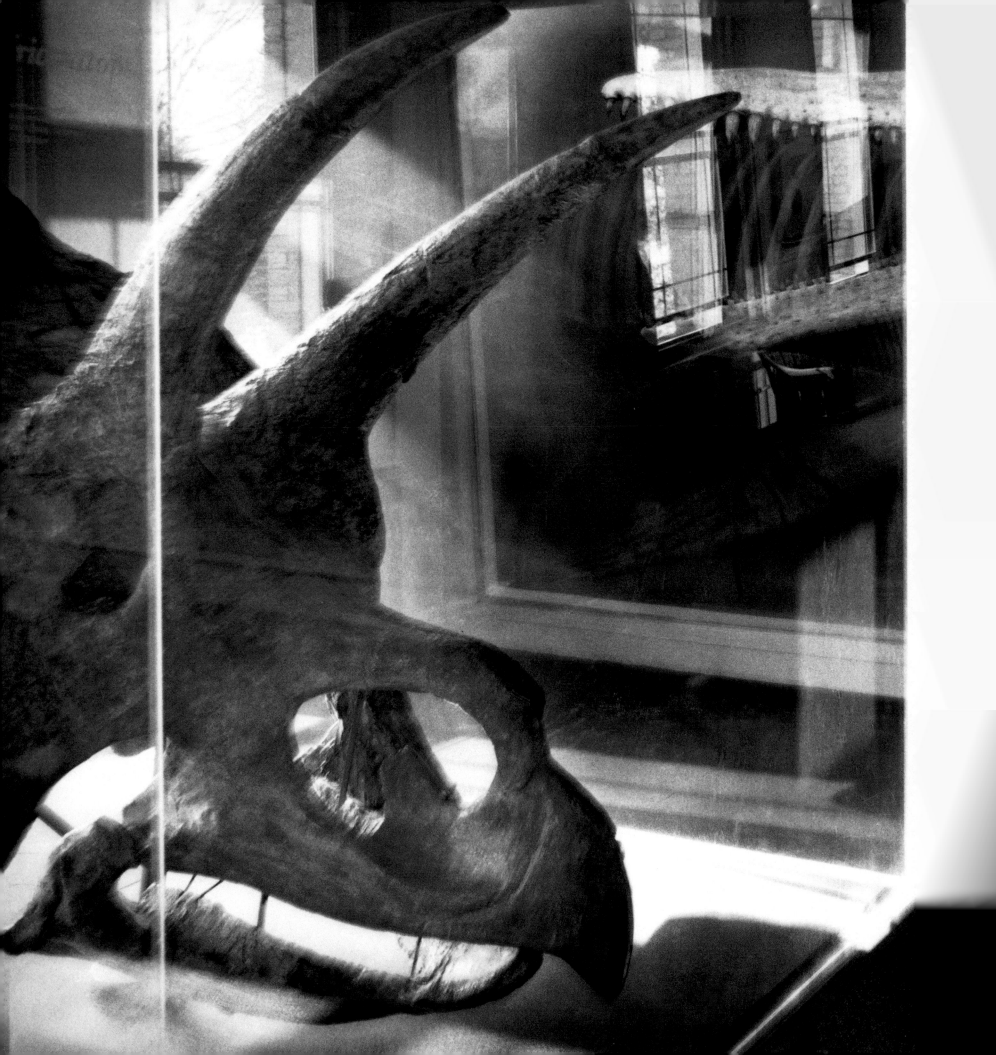

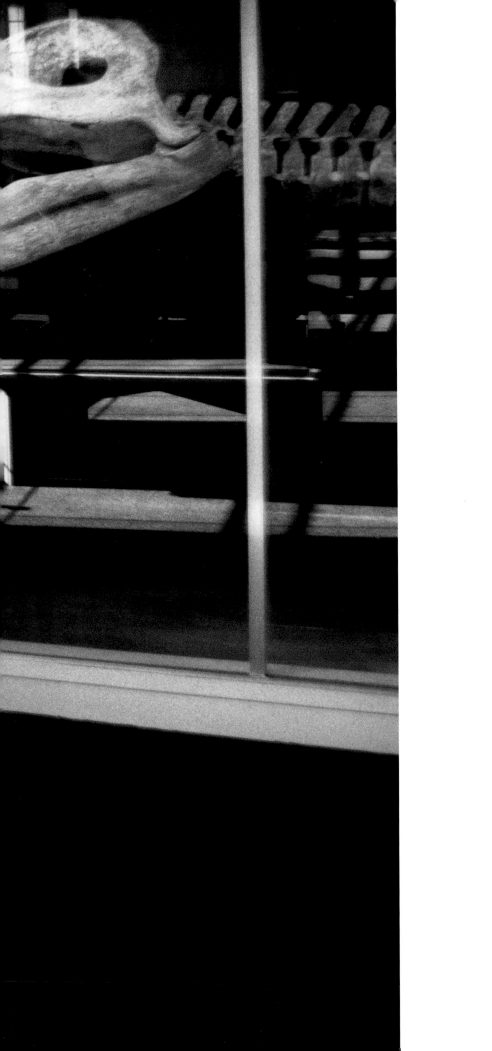

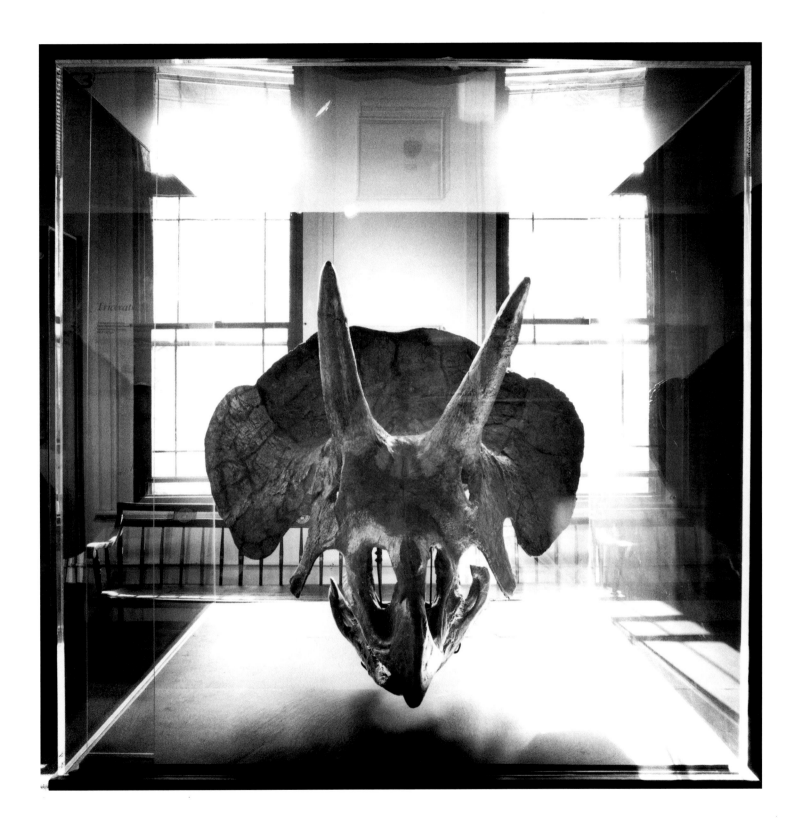

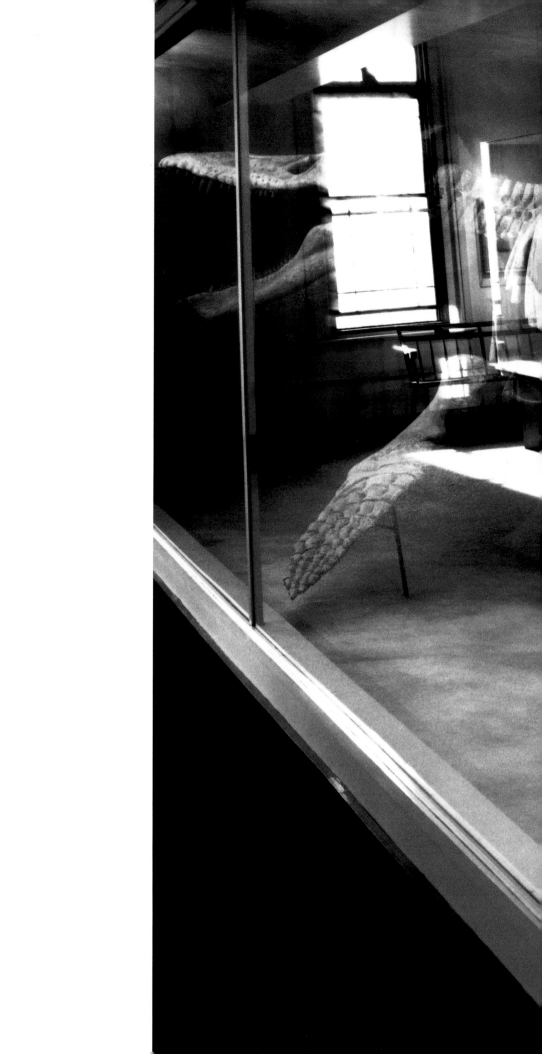

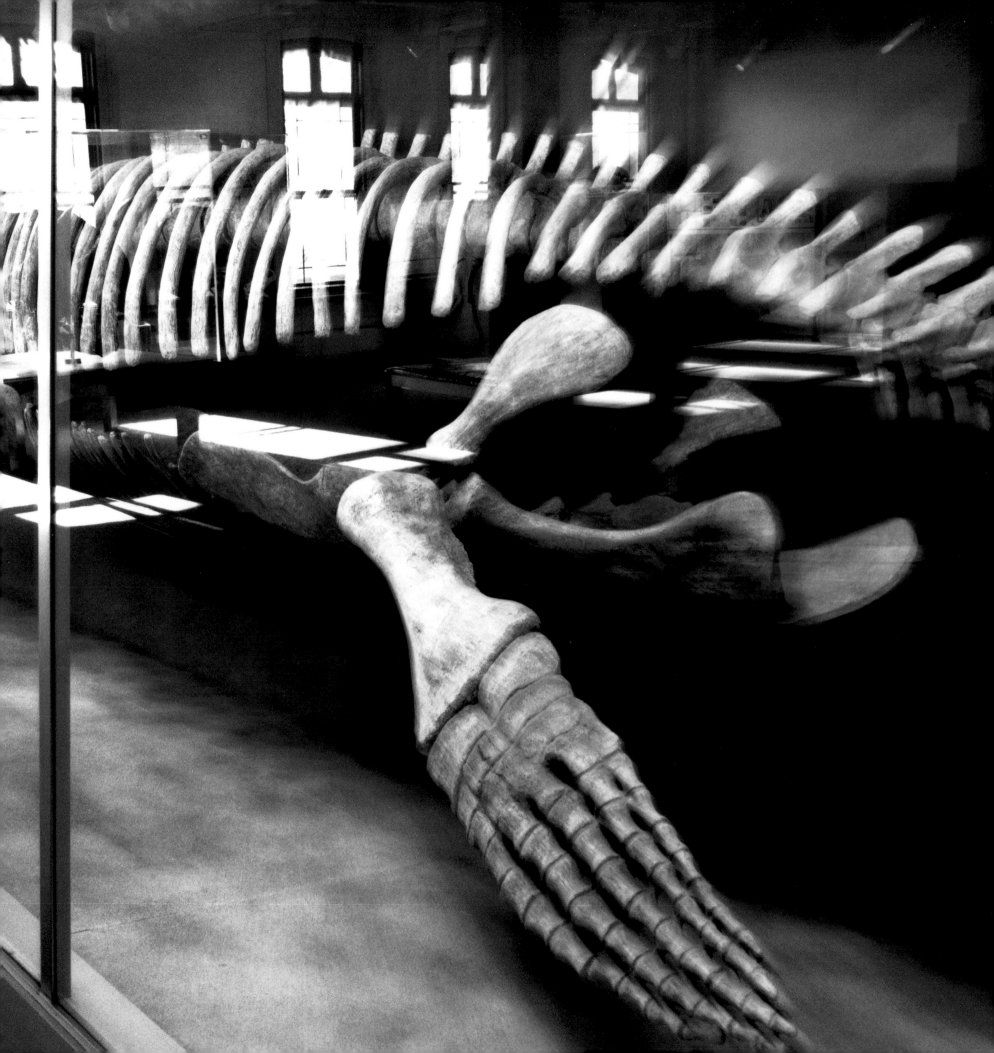

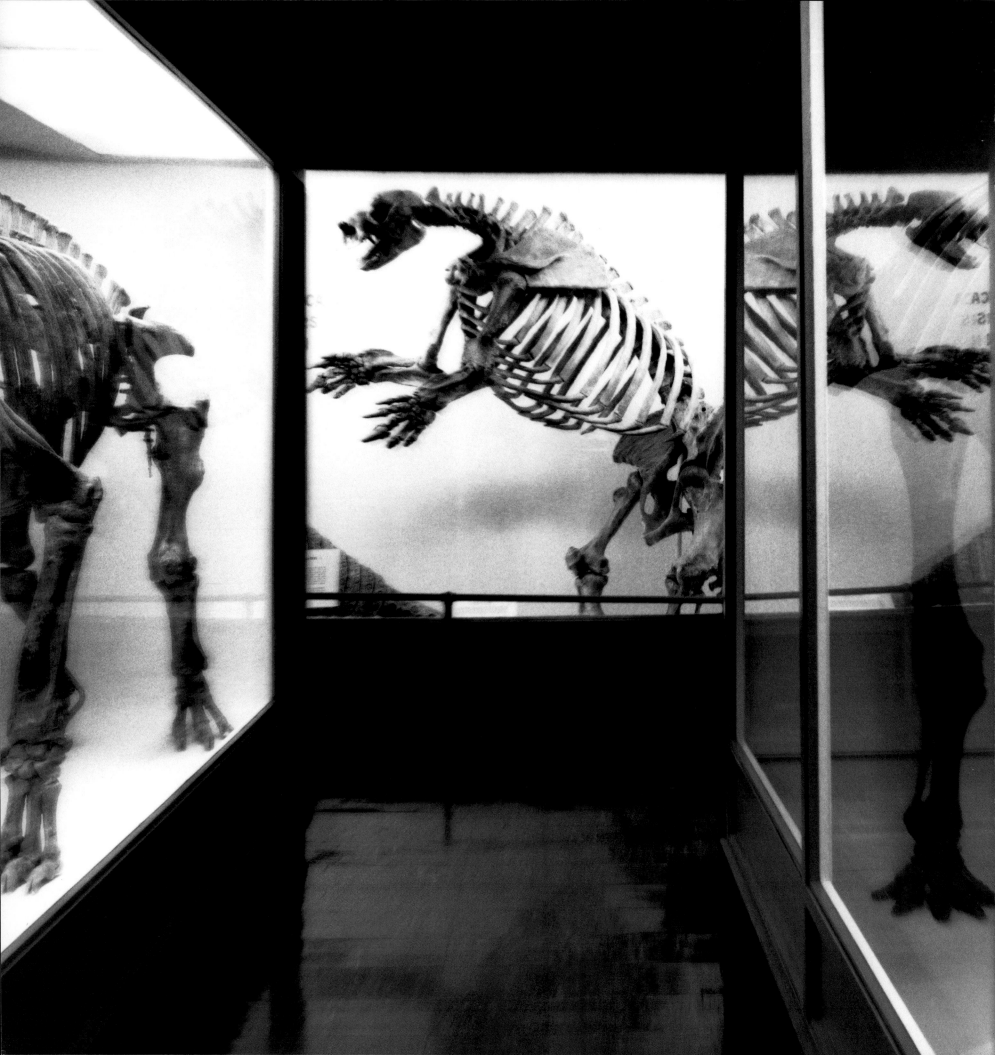

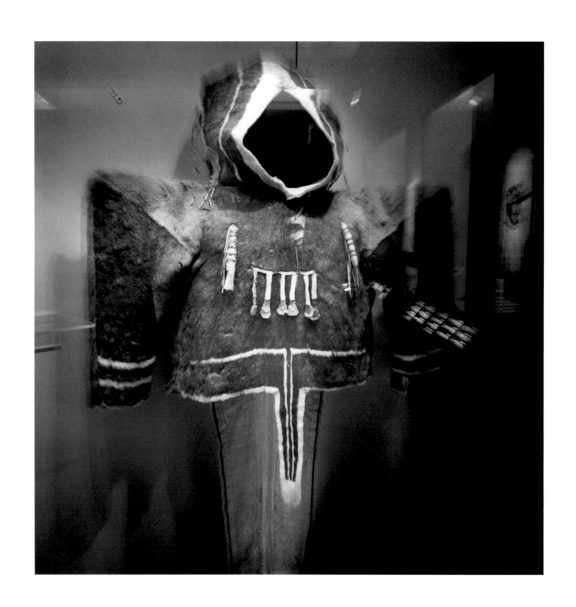

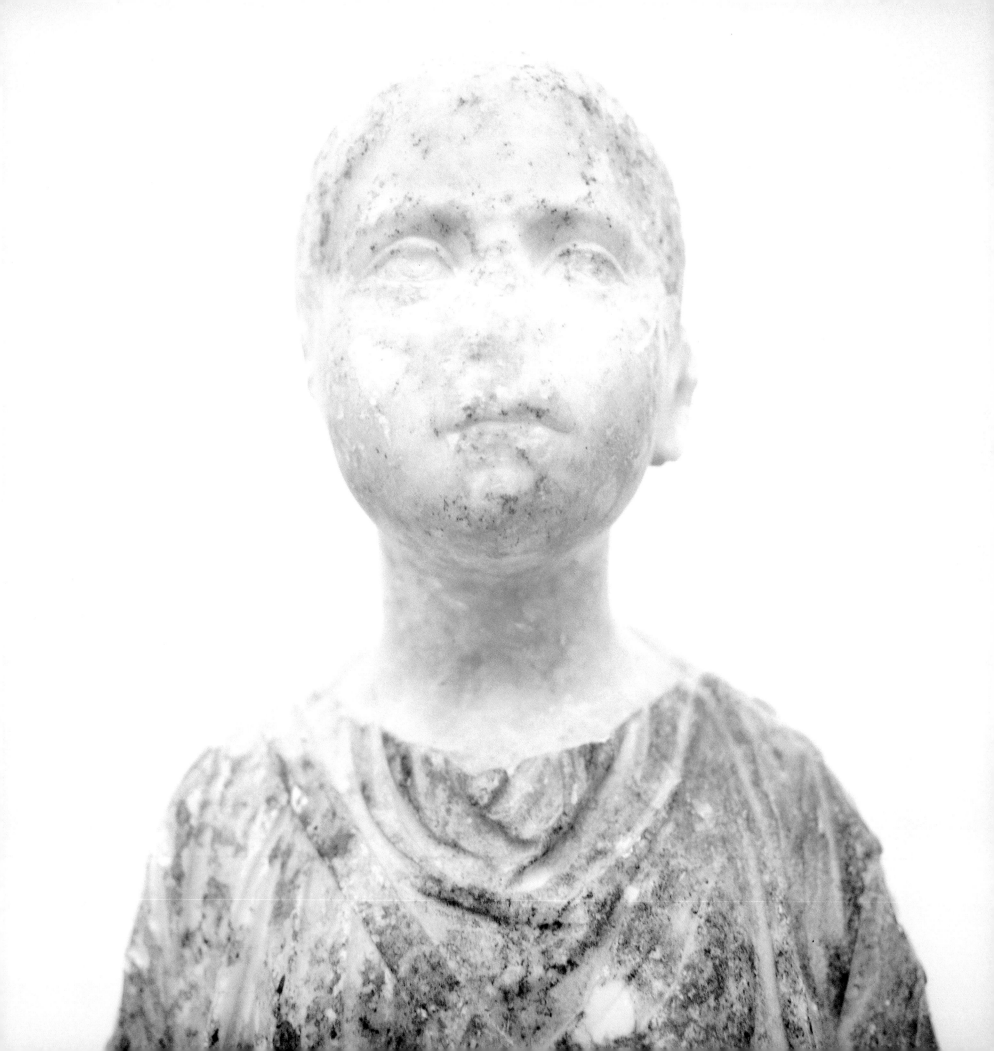

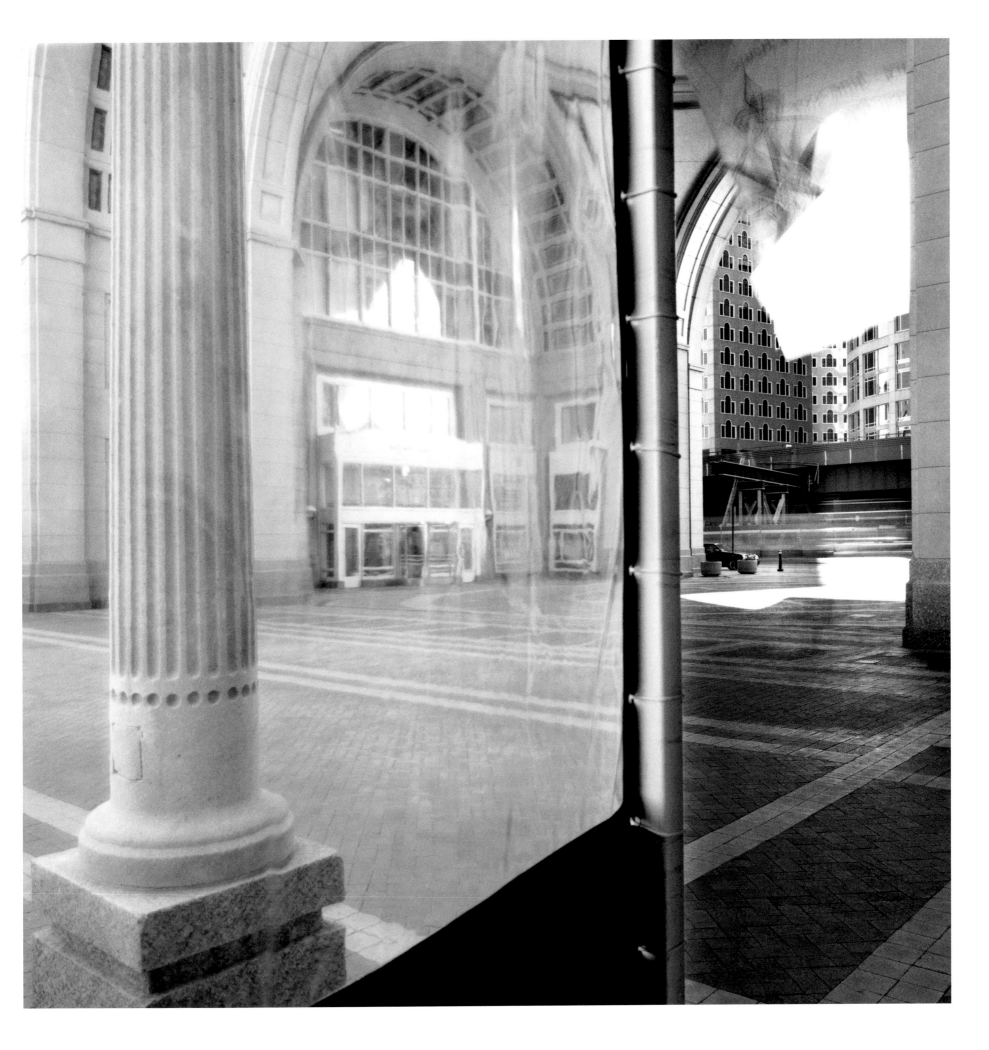

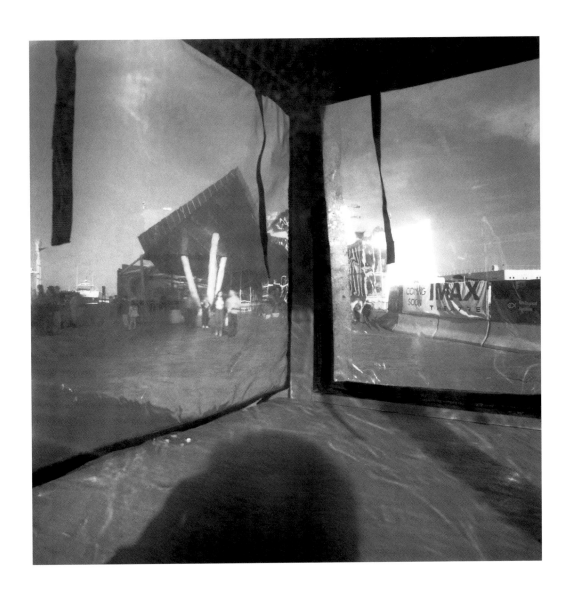

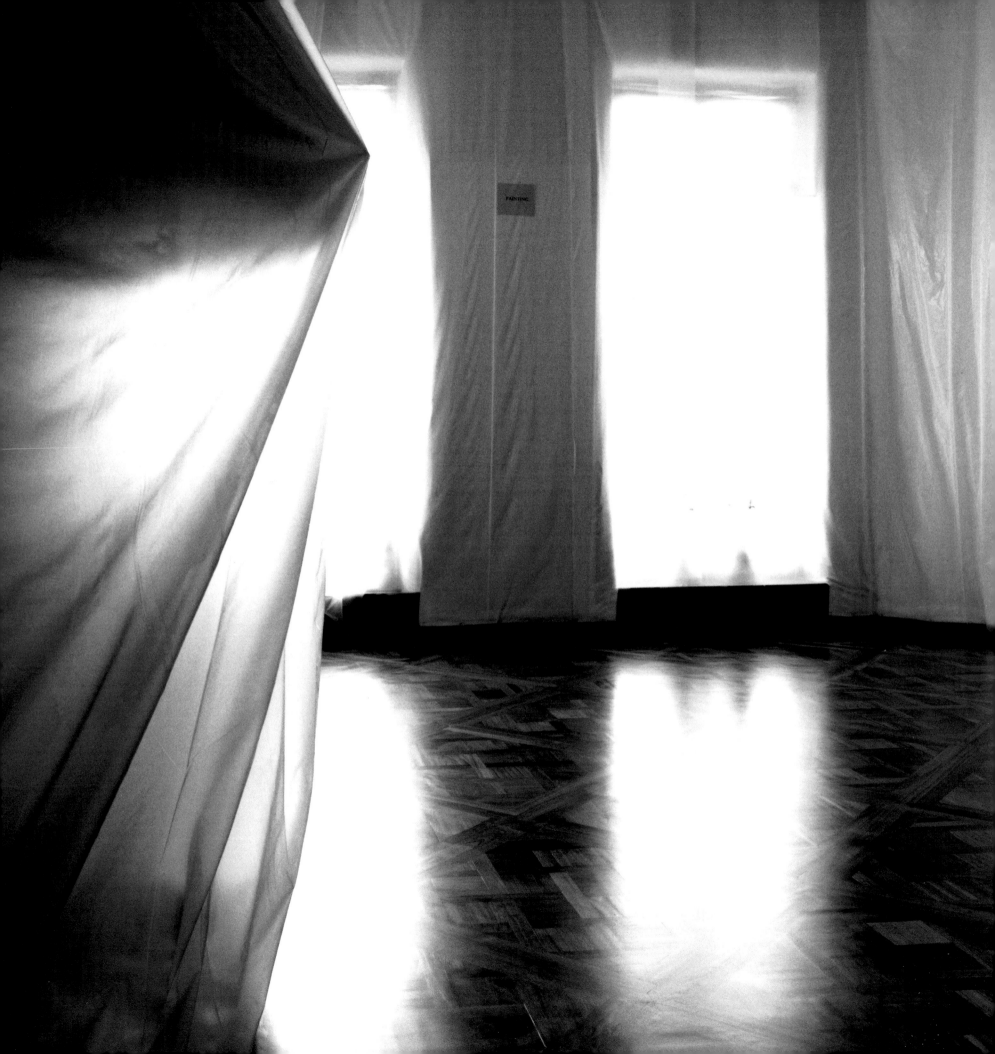

These pictures were taken in the spring of 2001.
Since then, the meaning and value of all our actions
and thoughts have been profoundly altered by the events
of 11 September.
I wondered what I should do with this book, which
is so "innocent" of the tragedy that has engulfed us.
After much soul-searching, I decided to proceed.
I believe that it is by going on with our work that
we can best express our opposition to the devastating
insanity that has invaded all our lives.

Mimmo Jodice

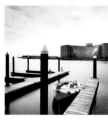

Federal Courthouse, Fan Pier

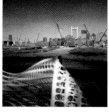

Boston Skyline

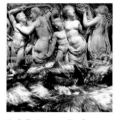

Isabella Stewart Gardner Museum

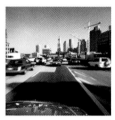

Boston Skyline

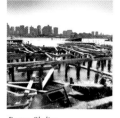

Boston Skyline

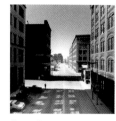

Boston Streetscape

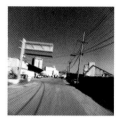

Charlestown

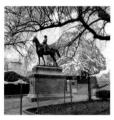

Major General Joseph Hooker Monument, Massachusetts State House

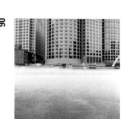

International Place

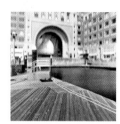

Rowes Wharf

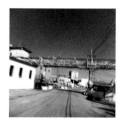

Boston Skyline

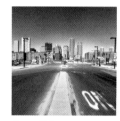

Charlestown

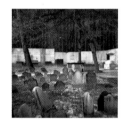

Old Granary Burial Ground

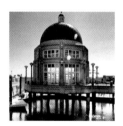

Pavilion, Rowes Wharf

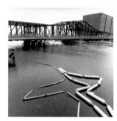

Old Northern Avenue Bridge

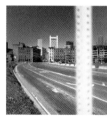

Boston Skyline

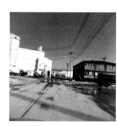

Charlestown

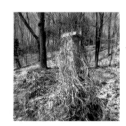

Deserted Greenhouse, Sudbury

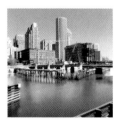

Financial District

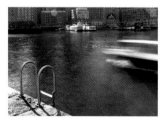

Boston Harbor

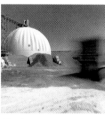

Charlestown

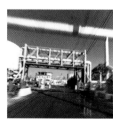

Charlestown

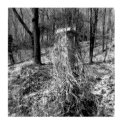

Codman House Grounds, Lincoln

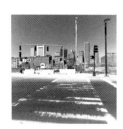

Boston Skyline

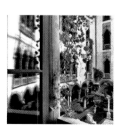

Isabella Stewart Gardner Museum

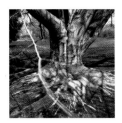

*Gore Place Grounds,
Waltham*

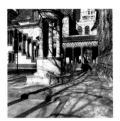

Trinity Church

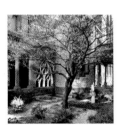

Trinity Church

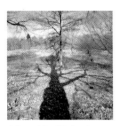

*Minute Man National
Historical Park, Concord*

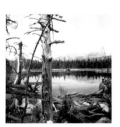

*Diorama, Boston Museum
of Science*

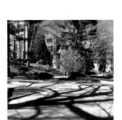

Wellesley College, Wellesley

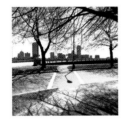

*Charles River and Boston
Skyline*

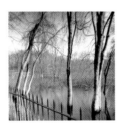

*Minute Man National
Historical Park, Concord*

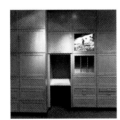

*John F. Kennedy Library and
Museum*

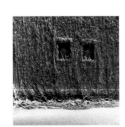

Charlestown

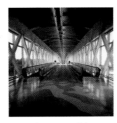

Logan International Airport

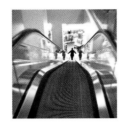

Copley Place

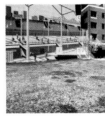

Mural, East Cambridge

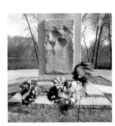

*Minute Man National
Historical Park, Concord*

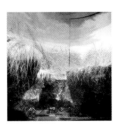

*Diorama, Boston Museum
of Science*

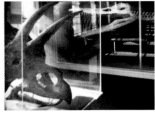

*Museum of Comparative
Zoology, Harvard University*

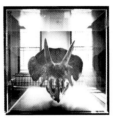

*Museum of Comparative
Zoology, Harvard University*

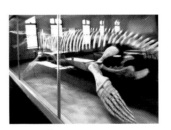

*Museum of Comparative
Zoology, Harvard University*

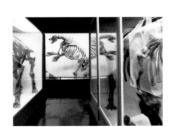

*Museum of Comparative
Zoology, Harvard University*

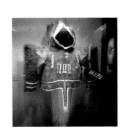

*Peabody Museum
of Archaeology and Ethnology,
Harvard University*

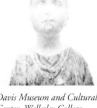

*Davis Museum and Cultural
Center, Wellesley College,
Wellesley*

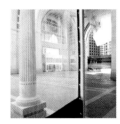

Rowes Wharf

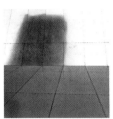

India Wharf

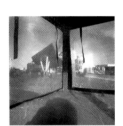

New England Aquarium

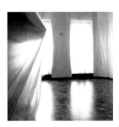

*Isabella Stewart Gardner
Museum*

Biography

Mimmo Jodice lives and works in Naples where he was born in 1934. Between 1970 and 1996 he was a professor at the Accademia di Belle Arti di Napoli.

An avant-gard photographer since the 1960's, attentive to experimentation and the expressive possibilities of the photographic language, Jodice has been a tireless protagonist in the cultural discourse in which he has helped to affirm and establish Italian photography and its position in the international sphere. Today Jodice is a central figure of reference for new generations who recognize in his work an original sensibility and a unique capacity for wisely marrying innovation with classical refinement. Jodice's first important exhibition was held in 1970 in Milan, at the Galleria Il Diaframma, with a text by Cesare Zavattini.

In 1980 he published *Vedute di Napoli* which signaled a shift in his language and contributed to a new vision of the Italian landscape and to a revision of its iconography.

In 1981, Jodice was invited to participate in the exhibition *Expression of Human Condition*, curated by Van Deren Coke and held at the San Francisco Museum of Art. On this occasion he exhibited with some of the most important contemporary photographers dedicated to confronting the alienated and disturbing face of modern man: Diane Arbus, Larry Clark, William Klein, Lisette Model.

In 1985 he began a long and thorough investigation of the myth of the Mediterranean. The result is a book, *Mediterraneo*, published in 1995 in New York by Aperture Foundation and translated and distributed in many countries.

For years he has maintained a place in the international panorama of art with numerous exhibitions and publications. He has had solo exhibitions in the following museums: Philadelphia Museum of Art, Philadelphia (1995); Kunstmuseum, Düsseldorf (1996); Museo di Capodimonte, Naples (1997); Maison Européenne de la Photographie, Paris (1998); Palazzo Ducale, Mantova (1998); The Cleveland Museum of Art, Cleveland (1999); Galleria Nazionale d'Arte Moderna, Rome (2000); Castel Nuovo, Naples (2000); Castello di Rivoli, Turin (2000).

He has published numerous books; among the most recent are *La Città Invisibile* (Electa 1990), *Passé Intérieur* (Contrejour 1993), *Mediterranean* (Aperture 1995), *Eden* (Leonardo Arte 1998), *Isolario Mediterraneo* (Motta Editore 2000), *Negli Anni Settanta* (Boldini e Castoldi 2000).

Works by Jodice grace such international collections as The San Francisco Museum of Art, San Francisco; Museo di Capodimonte, Naples; Yale University Art Gallery, New Haven; Castello di Rivoli, Turin; Maison Européenne de la Photographie, Paris; Galleria d'Arte Moderna e Contemporanea, Turin; Philadelphia Museum of Art, Philadelphia. In 2001 the Galleria d'Arte Moderna e Contemporanea di Torino dedicated to him a retrospective showing of his work from 1965 to 2000, complete with a comprehensive catalogue, curated by Piergiovanni Castagnoli.

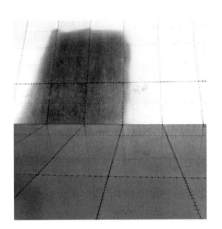

DATE DUE

GAYLORD PRINTED IN U.S.A.